IMAGES
of America

OYSTER BAY

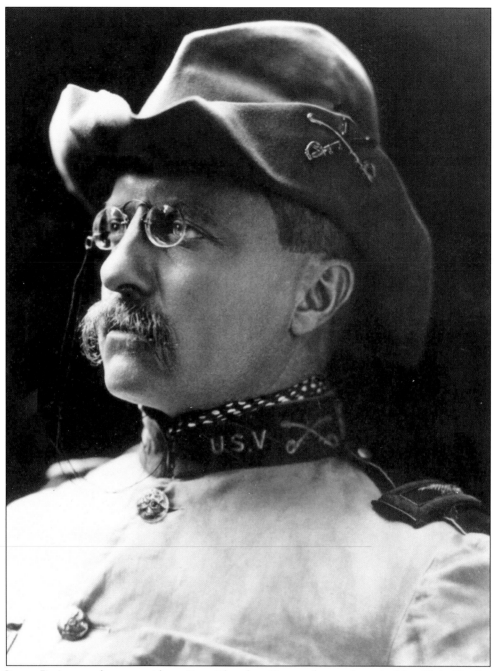

Oyster Bay's most famous resident, Pres. Theodore Roosevelt, was born in New York City but spent many of the summers of his youth at Oyster Bay where his father and grandfather both had summer homes. As an adult, Theodore Roosevelt chose Oyster Bay as his permanent residence where he built his home, Sagamore Hill. (Courtesy of the Theodore Roosevelt Collection at Harvard University.)

On the cover: Please see page 34. (Courtesy of the Oyster Bay Historical Society.)

IMAGES
of America

OYSTER BAY

John E. Hammond

ARCADIA
PUBLISHING

Published by Arcadia Publishing
Charleston, South Carolina

Printed in the United States of America

Library of Congress Control Number: 2009921634

For all general information contact Arcadia Publishing at:
Telephone 843-853-2070
Fax 843-853-0044
E-mail sales@arcadiapublishing.com
For customer service and orders:
Toll-Free 1-888-313-2665

Visit us on the Internet at www.arcadiapublishing.com

*Dedicated to the memory of those professional
and amateur photographers of the past who captured
the images we treasure today*

CONTENTS

ACKNOWLEDGMENTS

A book such as this could not be possible without the photographic images captured by so many professional and amateur photographers from long, long ago. Fortunately their work was preserved in private collections and historical organizations like the Oyster Bay Historical Society. I am particularly appreciative of my fellow trustees of the Oyster Bay Historical Society for allowing full access to the society's extensive photograph collection. Phil Blocklyn, archivist at the Oyster Bay Historical Society, was most helpful in guiding me through the collection and helping when computer glitches occurred. Thomas Ross, superintendent, Sagamore Hill National Historic Site; and Wallace Finley Dailey, curator, Theodore Roosevelt Collection, Harvard University, were very helpful in locating and allowing images for the chapter on Theodore Roosevelt. Linda Bruder encouraged me from the beginning to do this project and reviewed much of the material. She also offered many very valuable suggestions, almost all of which I adopted. From the very beginning of this project, Rebekah Collinsworth, editor, Arcadia Publishing, has been extremely helpful in answering my many questions, providing speedy answers, and giving timely suggestions for helping me through the process of developing *Oyster Bay*.

I want to acknowledge the extra effort of the Oyster Bay town clerk, Steven L. Labriola, in preserving and conserving the old records of the town, which will insure their availability to researchers of the future. I am most appreciative to the Honorable John Venditto, supervisor of the town of Oyster Bay, for his keen interest in the history of Oyster Bay and his unwavering support for all my historical projects.

Photographs appearing in this book are identified with letter codes after each caption. I want to thank each of the following organizations and individuals for allowing the usage of images from their collections: Oyster Bay Historical Society (OBHS), John E. Hammond (JEH), Friends of Raynham Hall Museum (FRH), Theodore Roosevelt Collection-Harvard College Library (TRC), Theodore Roosevelt Association (TRA), Nassau County Museum (NCM), Sagamore Hill National Historic Site (SAHI), Oyster Bay Railroad Museum (OBRM), Ron Youngs collection (RYC), Underhill Society in America (USA), and Oyster Bay Fire Company No. 1 (OBFC).

INTRODUCTION

The original inhabitants of Oyster Bay were the Matinecock Indians, who were here more than 1,000 years ago. Peter Stuyvesant, the Dutch director of New Netherlands, tells that the first settlement by Europeans anywhere on Long Island was by the Dutch at Oyster Bay in 1632. Although that 1632 Dutch settlement did not last, the Dutch continued to maintain influence in the area for many years. When the Dutch explorer David Pietersz DeVries sailed into Oyster Bay in 1639, he recorded in his journal that "he came to anchor in Oyster Bay. . . . There are fine Oysters here, whence our nation has given it the name Oyster Bay." When the first English settlement on Long Island was established at Oyster Bay in April 1640, the Dutch sent soldiers out to arrest and chase the settlers out of what they claimed as their territory. The English settlers then left Oyster Bay and went out east to establish a settlement at Southampton.

A little more than a decade later, in 1653, a new group of settlers arrived in Oyster Bay from Sandwich on Cape Cod and purchased the Town Spot from the Matinecock Indians. The legality of this purchase was contested by the Dutch, who asserted that the purchase was made in their claimed territory. The 1650 Treaty of Hartford had sought to clarify the Dutch/English boundary, but the issue was not finally settled until the Dutch were driven out of New Netherlands by the English in 1662.

The settlement at Oyster Bay came under heavy Quaker influence in the 1660s, and the Quaker founder, George Fox, preached at Oyster Bay in 1671. This led to the erection at Oyster Bay of the first Quaker meetinghouse in New York in 1672. The influence of the Quakers led to the refusal of local freeholders to sign the loyalty oath required in the English land patents, and it was not until they were threatened with the total loss of all their rights to the lands they had purchased from the Native Americans that the freeholders at Oyster Bay finally agreed to sign the Andros Patent in 1677.

A century later, the small village became involved very early in the events that led to the Revolutionary War, when the Sons of Liberty met in Oyster Bay as early as 1765. During the Revolutionary War, Oyster Bay and all of Queens County came under British control much to the chagrin of most of the residents. Many were pressed into service with the occupying British forces. Some became active spies, like Robert Townsend, while others, like Capt. Daniel Youngs, did everything possible to interfere with the British war efforts. Raynham Hall, the home of Samuel Townsend, was commandeered by the commander of the Queens Rangers, Lt. Col. John G. Simcoe, as his headquarters. It was at Raynham Hall that Maj. John Andre often met with Colonel Simcoe. Major Andre was executed shortly afterward for his involvement with Benedict Arnold and his plan to turn over West Point to the British. After the war, when Pres. George

Washington made his tour of Long Island, one of his stops included the Youngs homestead in Oyster Bay Cove, the home of Capt. Daniel Youngs, who had been pressed into British service during the war.

In the middle of the 19th century, Oyster Bay became a favored destination for many of the wealthy residents of New York City hoping to escape the oppressive conditions present there in the summertime. Among this group were the Beekmans, Louis Comfort Tiffany, and Cornelius Van Schaak Roosevelt, who brought along his son Theodore Roosevelt and grandson Theodore (later to become Pres. Theodore Roosevelt). Upon the death of Cornelius in 1870, Theodore Roosevelt's father began renting a summer home at Oyster Bay named Tranquility. Later Theodore Roosevelt chose Oyster Bay as his permanent place of residence when he purchased property on Cove Neck from the Youngs family and began building Sagamore Hill in 1880. He set up permanent residence at Sagamore Hill in 1886. Oyster Bay remained his home throughout his life. Upon his death at Sagamore Hill in 1919, Theodore Roosevelt was buried at Youngs Memorial Cemetery, just across the street from the Youngs homestead, where George Washington had rested overnight little more than a century earlier.

The Long Island Railroad extended the rail line from Locust Valley to Oyster Bay in June 1889. The railroad provided fast and reliable transport into the city and resulted in many of the summer residents becoming year-round residents. The surrounding area expanded rapidly in the early 20th century as many old family farms were purchased and turned into Gold Coast estates, but the small hamlet retained much of its essential character, which had developed from the early Dutch and English settlements and its close connection with the water.

One

THE EARLY YEARS

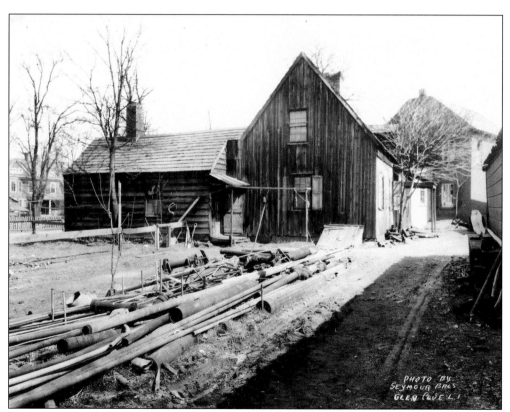

Peter Wright was the only one of the three original purchasers of the Town Spot in 1653 that actually stayed in Oyster Bay. Peter Wright died between 1660 and 1663. Job Wright, a son of Peter Wright, inherited land from his father and was given additional land by his uncle Anthony Wright on which he built this house about 1665. Although the house was torn down in 1949, a section of the interior was preserved in what is known as the Oyster Bay Room of the Winterthur Museum in Delaware. (OBHS.)

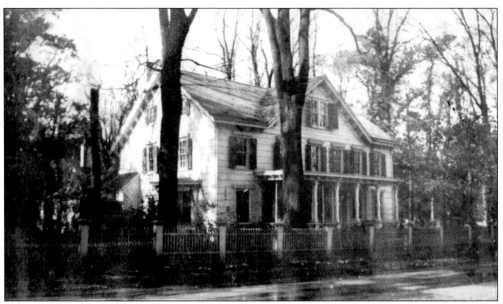

Job Wright was a builder and built many of the early houses in Oyster Bay. He built the original part of this house on Lexington Avenue in 1686. The house was added to several times by successive owners. This photograph was taken in 1918. The building survived well into the 20th century, only to be torn down to make way for a housing project. (JEH.)

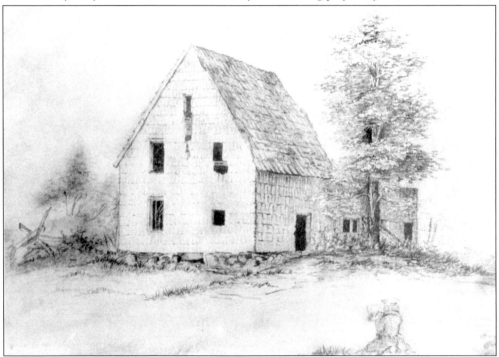

In 1682, Simon Cooper, a chirurgeon, as surgeons were then called, acquired 400 acres on Cove Neck and built this home. This drawing of Dr. Cooper's house was done in 1832 by John Abeel Weeks of Oyster Bay, who later became the president of the New York Historical Society. The house did not survive to the advent of photography. (OBHS.)

In 1681, Simon Cooper purchased this house, which was built by John Richbell about 1660. The original east wing of the residence contained a nine-foot-wide fireplace where all the cooking was done. Refine Weeks built the main section of the house in 1786, and being that it was later owned by four generations of the Albertson family, it became currently known as the Albertson House. (OBHS.)

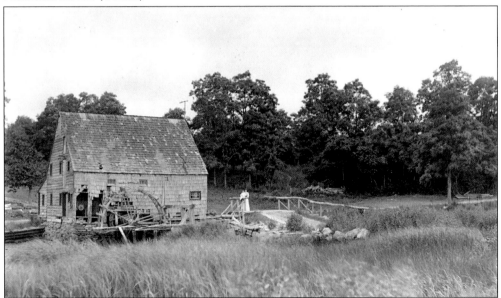

This undershot mill was built by John Feeks and Henry Townsend about 1690. The mill was at Papaquatunk Creek, which was the western boundary of the 1653 Town Spot purchase. The location is presently known as Beaver Dam. This photograph was taken by Dr. George Washington Faller in 1895. The mill was razed in 1911. (OBHS)

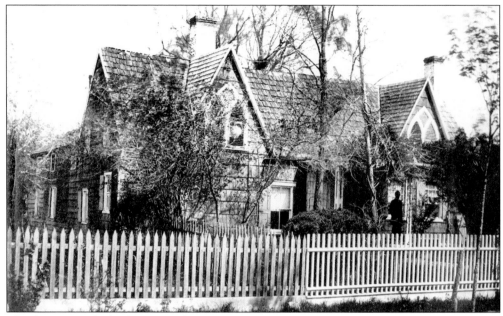

This house was built about 1660 by Thomas Townsend, who in 1695 gave it to his daughter Freelove and her husband Maj. Thomas Jones. They did not stay there long, and the house was later owned by the Weeks family and then the Burtis family. It came to be known as the Burtis-Weeks House and was torn down in 1902 to build a parsonage for the Methodist church. (OBHS.)

The Burtis-Weeks House was built at a time when there was still a fear of Native American raids. Thomas Townsend built the walls very thick and positioned gun port openings on all four sides. Over the years there were many additions to the building before it was torn down. The steeple of the 1895 Methodist church can be seen to the right of the house. (OBHS.)

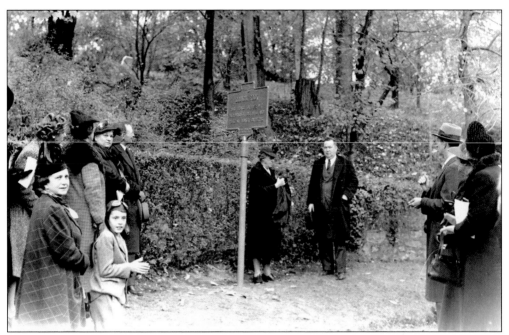

George Fox, the founder of the Quaker movement in America, came to Oyster Bay to speak and advocate Quakerism in 1671. He spoke for several days, perching atop a large rock at a spot overlooking the millpond. The rock came to be known as Council Rock. This photograph shows the 1941 dedication of the New York state historical marker for Council Rock. (JEH.)

During his meetings at Oyster Bay in 1671, Fox suggested to the community that they build a meetinghouse. The following year, the first Quaker meetinghouse in New York was built in Oyster Bay near the present-day corner of South Street and Audrey Avenue. In 1899, the building was moved further back from the corner and converted to an automobile service and bicycle sales shop. It was torn down just after World War II to build a parking lot. (JEH.)

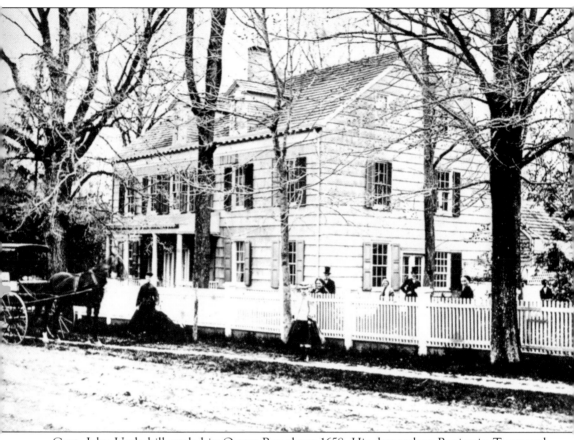

Capt. John Underhill settled in Oyster Bay about 1658. His descendant Benjamin Townsend Underhill bought this house in 1817, three years after his marriage to Elizabeth Weeks. The house was reportedly built in the 1600s by John Wright. This photograph, taken about 1870, shows many of the members of the large Underhill family. The building survived until the 1960s, when it was torn down to make way for an apartment complex. (OBHS.)

Elizabeth Weeks, born on March 7, 1793, was the oldest child of James Weeks and Miriam Doughty. She married Benjamin Townsend Underhill on January 12, 1814, at her father's home on Cove Hill. She died in her home on Lexington Avenue at age 90 on August 26, 1883. (OBHS.)

The Underhill home remained in the possession of the Underhill family and descendants for a century and a half. The last owner of the house was Edith Weeks Slade, great-granddaughter of Benjamin Townsend Underhill. Shown in this photograph are Maria (1817–1914) and Eliza Underhill (1822–1915), who lived in the house almost their entire lives. (OBHS.)

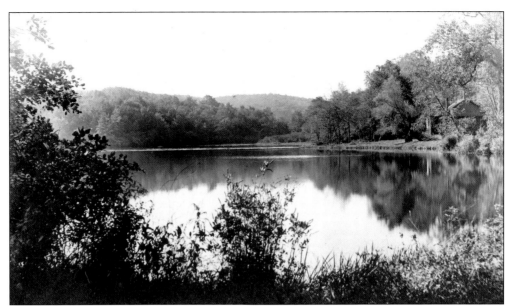

John, Henry, and Richard Townsend settled in Oyster Bay in the spring of 1661. Henry Townsend was given a grant by the freeholders of the town to dam up the river and erect a mill for the grinding of grain. The land and rights to the river would continue with Henry and his descendants as long as there was an operating mill. Henry built the first mill very near the location of the house seen in this c. 1900 photograph, taken by Dr. George Washington Faller. (OBHS.)

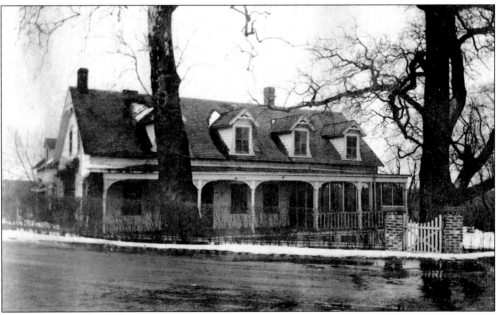

This house was built sometime prior to 1705 by John "Mill John" Townsend, son of Henry Townsend. After Mill John's death, his widow Esther Townsend became one of the earliest female entrepreneurs when she obtained a sloop and entered the coastal shipping trade. Her main cargo was cider from the local cider mills and her sloop quickly became known locally as the "Old Cider Tub." (JEH.)

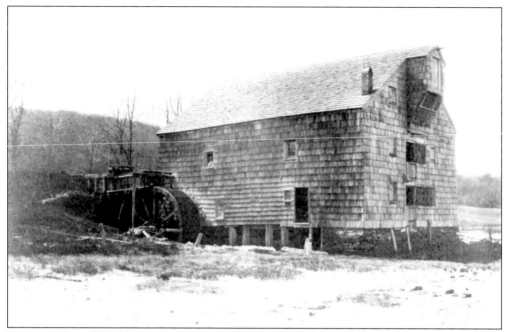

This mill along Shore Road was built in 1797 and replaced two earlier mills. An overshot mill, it was fed by water from the millpond, which reached the mill by way of a sluiceway running along Shore Road. This mill ceased operations sometime in the 1880s and was converted into a residence before being torn down about 1905. (JEH.)

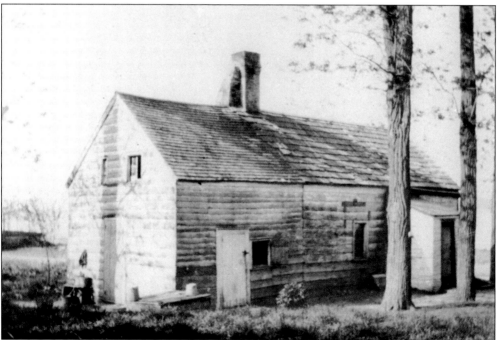

Henry Townsend built additional mills and began hiring others to run some of them. On the hill behind the mill on Shore Road, this house was built about 1668 by Henry Townsend for the use of the miller who operated the mill at the Oyster Bay Mill Pond. (OBHS.)

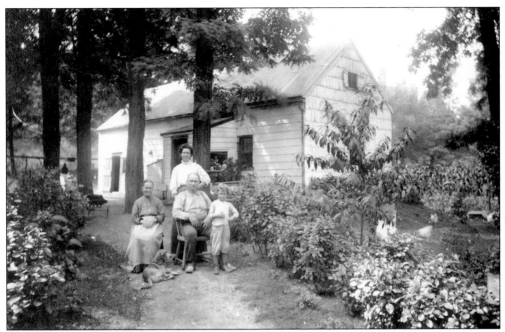

The miller's house remained in usage for more than 200 years. This 1912 photograph shows Civil War veteran Wellington Appleford, his wife Elizabeth, and their daughter Ida Verity with her son Frank Verity Jr. The dog was named Teed. The house was destroyed by fire in 1924. (OBHS.)

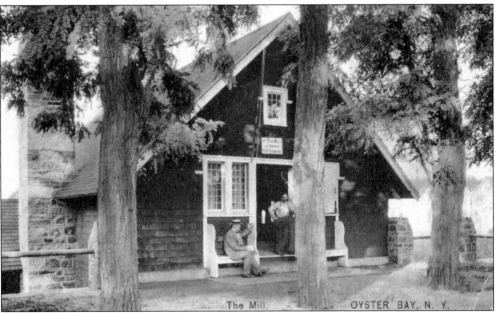

When the mill along Shore Road was torn down about 1905, Beekman Townsend was threatened with the loss of his inherited property. In order to keep his title to the land, which required an operating mill, he had this mill constructed at the millpond. Although the sign on the front read "The mill is ready for grinding," the mill was never used for grinding even a single pound of grain. In 1922, it was destroyed by fire. (OBHS.)

Samuel Townsend was a fifth-generation descendant of John Townsend, who had come to Oyster Bay in 1661. Samuel was born and raised in Jericho but in 1740 bought this house on West Main Street in Oyster Bay. A Whig at the time of the Declaration of Independence, Samuel was arrested by British forces in July 1776 while sitting on his front stoop. (OBHS.)

Jacob Townsend moved into this house on West Main Street, which was next door to his brother Samuel. Jacob died in 1773, shortly before the Revolutionary War broke out, and was buried in his family's plot in Jericho. His daughter Hannah became involved with Maj. Joseph Green, a British officer, and after the war they married and went to live in Ireland. (JEH.)

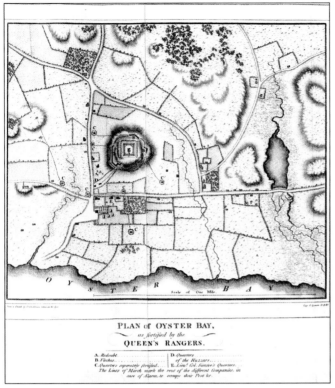

PLAN of OYSTER BAY,
as fortified by the
QUEEN'S RANGERS.

A. Redoubt.................
B. Fleches..................
C. Quarters separately fortified..
The Lines of March mark the road of the different Companies, in case of Alarm, to occupy their Post &c.

D. Quarters
of the Huzzars............
E. Lieut. Col. Simcoe's Quarters....

Samuel Townsend's home, known as Raynham Hall, was commandeered by the British during the Revolutionary War. Lt. Col. John Graves Simcoe used the house as headquarters for his Queens Rangers. Colonel Simcoe had several meetings here with Maj. John Andre, who was convicted of plotting with Benedict Arnold to turn over West Point to the British. Colonel Simcoe drew this map of the fortifications at Oyster Bay for publication in his journal after the war. (JEH.)

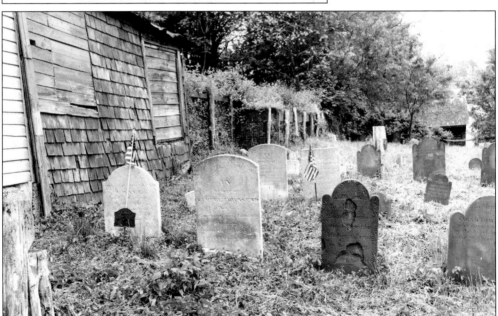

Robert Townsend, son of Samuel Townsend, served as a spy for George Washington during the Revolutionary War. Robert Townsend, who operated under the code name of Culper Junior, was considered by Washington to be his best and most reliable spy. Robert Townsend died in 1838 and was buried in the family cemetery shown here. The cemetery is located on Fortified Hill, only steps away from the location of the British Revolutionary War fortification. (OBHS.)

Capt. Daniel Youngs was believed by many to also have been a spy for George Washington. Youngs grew up in the family homestead, which was built by his ancestor Thomas Youngs about 1665. During his April 1790 tour of Long Island, Pres. George Washington recorded remarks in his journal about the pleasant conditions of his overnight stay at the Youngs homestead in Oyster Bay. (JEH.)

In 1705, William Wright built this house on West Main Street. Wright was born in 1680 and died at Oyster Bay in 1759. He was a son of Elizabeth Dickinson and Caleb Wright. Elizabeth Dickinson's father, John Dickinson, had been the captain of the sloop *Desire*, which brought the first purchasers to Oyster Bay from Sandwich on Cape Cod in April 1653. Captain Dickinson's wife, Elizabeth Howland, was a daughter of John Howland of the *Mayflower*. (OBHS.)

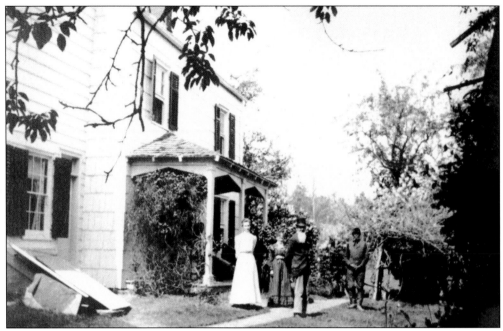

The William Wright homestead was expanded several times by successive generations of Wrights. This photograph, taken near the back door of the home on May 22, 1904, shows, from left to right, Mary Wright, Julia Wright, and John Wright, along with the family servant, Nelson Treadwell. (OBHS.)

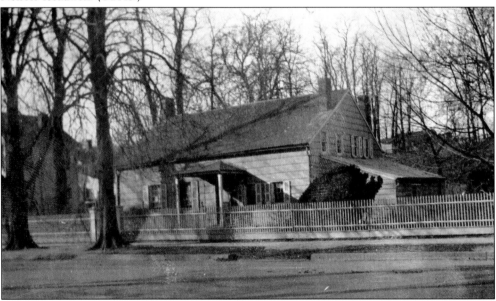

This house stood on South Street for more than 200 years before it was moved to Summit Street, where it became the home of the Oyster Bay Historical Society. Today the house is known as the Earle-Wightman House in recognition of Rev. Marmaduke Earle and Rev. Charles S. Wightman, who both lived there. Earle served as pastor of the Oyster Bay Baptist Church from 1801 to 1856. Wightman, who married Earle's granddaughter, served as pastor at the same church from 1868 to 1933. (JEH.)

Two

VILLAGE LIFE

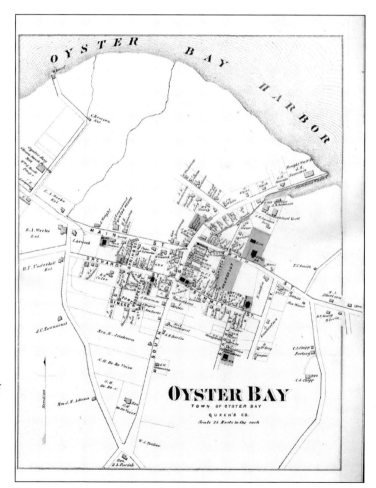

This map of Oyster Bay is from the Beers, Comstock and Kline Atlas of Queens County of 1873. Oyster Bay was then a part of Queens County. When Queens County became a part of New York City in 1899, the three eastern towns of Hempstead, North Hempstead, and Oyster Bay formed the new Nassau County. (JEH.)

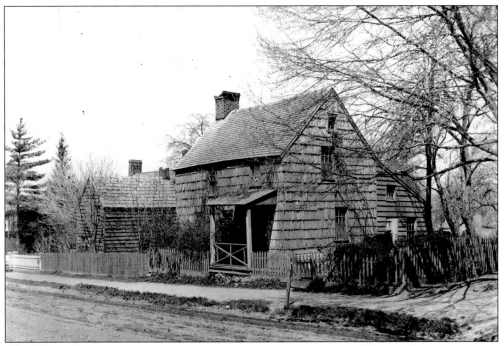

The Wilson House on East Main Street was reportedly built about 1752. Local legend says that Pres. George Washington spoke from the porch of the house during his April 1790 tour, but the legend is not supported by any mention in Washington's journal of his visit. (JEH.)

Henry Wilson was born in 1804 in Sweden. Rev. Charles S. Wightman, pastor of the Oyster Bay Baptist Church, related in his journal the difficulties he had for many years trying to teach Wilson the English language. Wilson was a cooper (barrel maker) by trade, and he died in 1875. His wife and daughter Gertrude died the same day in 1899. (JEH.)

Charlotte Aurelia Winder Townsend was born in Baltimore and married James C. Townsend of Oyster Bay. Charlotte's brother, Gen. John Winder, was the Confederate general in charge of prisons who designed the infamous Andersonville Prison. During the period of the Civil War, Charlotte and her husband researched the history of the Townsends in Oyster Bay, which resulted in the publication of the *Townsend Memorial*. Charlotte was murdered at her Lexington Avenue home in 1884. (JEH.)

One hundred and twenty-four young men from the Oyster Bay area served in the Harris Light Cavalry during the Civil War, including Jeremiah Davis, shown here. Private Davis was captured at Spotsylvania and imprisoned at Libby Prison. Four young men from Oyster Bay who were members of the Harris Light Cavalry were captured and imprisoned at Andersonville, where they died. (JEH.)

Stephen Decatur James enlisted in Company C, 102nd New York Regiment, on August 23, 1862. Private James fought in many battles and survived the war without injury. After the war, James was a bartender at the Trout Pond Inn on Bay Avenue, which was owned by John Franklin, who served three years in the Civil War with the 3rd Missouri Cavalry. Franklin kept his trout in a fresh spring-water pond at the hotel along with kegs of beer. One day a beer barrel sprung a leak and the trout reportedly got drunk and were crashing into the sides of the pond. Theodore Roosevelt was reported to have almost fallen off his chair in a laughing fit when told the story. (JEH.)

Some Civil War photographs were actually combinations of photographs and paintings, as is this image of John Wansor, who was born in Oyster Bay in February 1835. Wansor enlisted in Company C of the Harris Light Cavalry on September 1, 1862. He was discharged on June 5, 1865, and returned to resume his life as a farmer. His home was on the corner of Oyster Bay Road, the present day site of Barney's Corner in Locust Valley. (JEH)

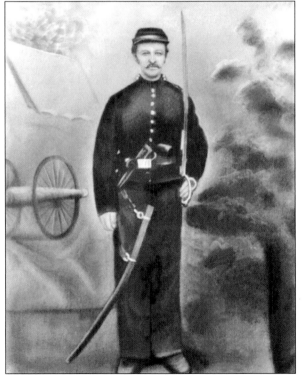

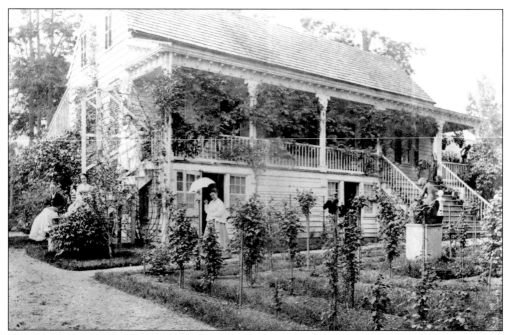

The Alger Cottage on Cove Road takes its name from longtime owner Madame Jacques Alger, who died in 1925. At one time the *c.* 1800 building was a feed and grain store. It had unusually thick walls and an ancient cellar. This photograph was taken about 1870 and shows several of the ladies who then lived in the house. (OBHS.)

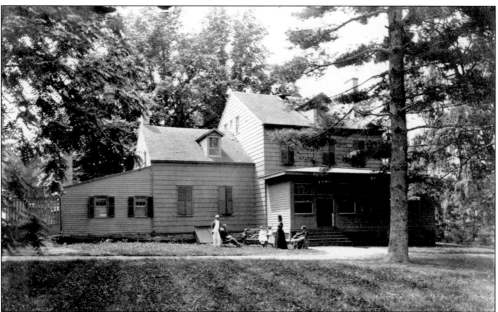

Shown in this 1868 photograph are John Abeel and Alice Hathaway Weekes and their children. The house was built in 1809 by James Weekes and was later owned by Dr. James DeKay, the noted author of the birdlife section of the multivolume *History of New York*, commissioned by Gov. William Marcy in 1835. In 1835 and 1836, Dr. DeKay was one of the town of Oyster Bay's inspectors of common schools. (JEH.)

This house on Mill Hill was built by chancellor William T. McCoun in 1834. McCoun was elected the first chairman of the newly formed Republican Party in New York State at the convention at Saratoga Springs on August 16, 1854. Four years later, McCoun led the New York delegation at the national convention where Abraham Lincoln was nominated in 1860. (JEH.)

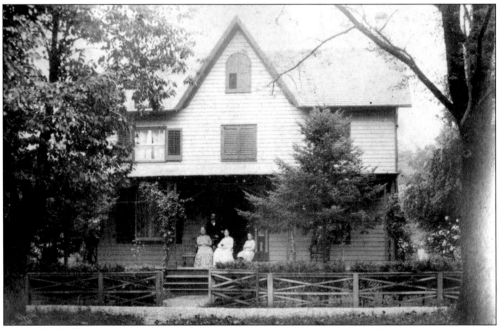

Samuel Y. Ludlam was one of the delegates at the Queens County Republican Party meeting at Mineola on July 20, 1854, that selected William T. McCoun as its chairman. Ludlam was from a family that had settled in Oyster Bay in the 1600s. Samuel and his family pose on their South Street porch in the 1870s. (JEH.)

Dr. Ebenezer Seely built this house on West Main Street in 1830. In this 1889 photograph are, from left to right, Eugenia, Aurelia, Alice, George, Leonard, grandfather Caleb Wright, and Leonard Blum. Dr. Seely served as supervisor of the Town of Oyster Bay and a family story persists that he entertained the eighth president of the United States, Martin Van Buren, in this home. (OBHS.)

Ebenezer Seely's daughter Catherine married Joseph Buffett Wright and inherited the house. In the 1890s, a large gable addition was made to the Seely-Wright house giving it the look enjoyed today. Many years later, the bowed fence that is present today was also added. The house is noted for its unusual Greek Revival trim. (JEH.)

In 1835, Ebenezer Seely sold a portion of his land to Rev. Marmaduke Earle. Shortly after that sale, Seely also sold a portion of his land that became Orchard Street. The Ludlam family built this house on Orchard Street just opposite Spring Street. (JEH.)

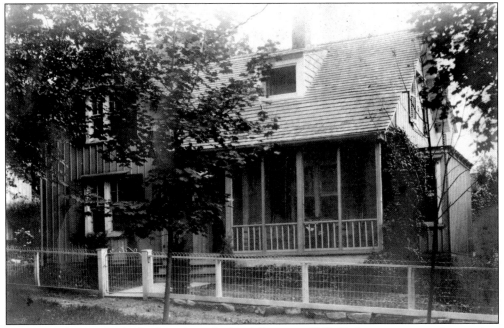

George Dickenson built this house on Orchard Street in 1857. Dickenson operated a window blind factory in another building on Orchard Street. His factory building later became a school operated by the granddaughters of Rev. Marmaduke Earle. (JEH.)

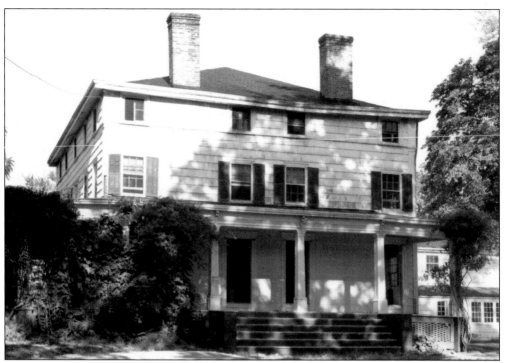

This pre–Revolutionary War residence was known for many years as the office and home of Dr. Wicker Jackson and her husband Dr. Myron Jackson. Dr. Wicker Jackson was the attending physician who brought the author of this book into the world. The building was demolished in 1970 to make way for a parking lot for new car sales. (JEH.)

This house at the base of Mill Hill was built at an early date. This photograph was taken in 1895, when it was occupied by the McCoun family. In the rear of the residence there was a large flower and vegetable garden. In front of the building there was a bridge allowing water from the millpond to pass underneath on its way down to the mill along Shore Road. (OBHS.)

The home of Sidney Lewis, at 51 Tooker Avenue, is seen as it appeared in 1907. Tooker Avenue takes its name from William A. Tooker, who owned large tracts of property in the village in the 1800s. Tooker Avenue was not laid out as a street until the 1880s. (OBHS.)

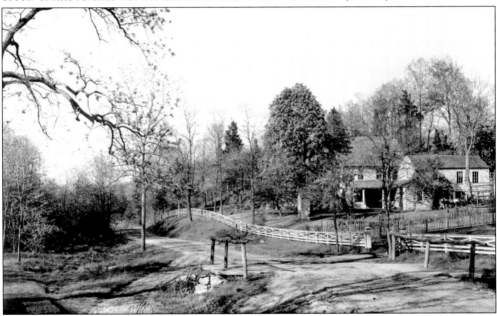

In the 18th century there were many small family farms surrounding the hamlet of Oyster Bay. The Horton family farmhouse was typical and stood on Mill River Road, or Poverty Hollow Road as it was then called. Poverty Hollow takes its name from the British foraging troops during the Revolutionary War who could find nothing of value in the area, thus a "poverty hollow." (OBHS.)

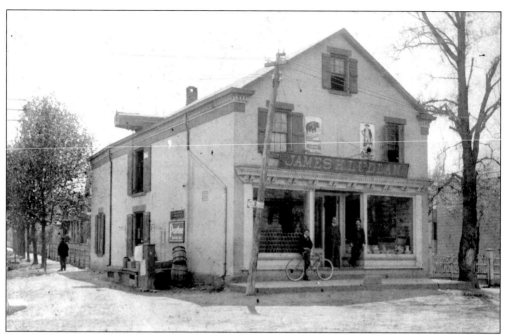

In November 1848, James Ludlam lost his dry goods business when his store on the corner of Spring Street and West Main Street was destroyed by fire. Ludlam was determined to not have that happen again and built this brick building in 1849 on the corner of West Main Street and South Street. The protrusion from the roof at the left side of the building is a mechanism to hoist goods to the second-floor loft storage area. (OBHS.)

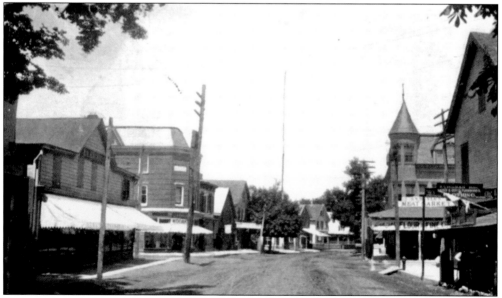

This 1906 view of South Street shows the Elbert Hegeman dry goods store in the left foreground and the Joseph Randall building on the left corner. The pole in the center of the photograph was the village liberty pole. Liberty poles were long a tradition in the village and were used to commemorate the independence of the country. An earlier liberty pole was on East Main Street in front of the store of Richard Sammis. (JEH.)

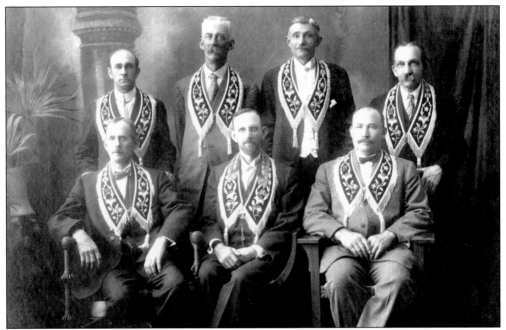

The Independent Order of Odd Fellows met in a room on the second floor of the Joseph Randall building. Seen here from left to right are (first row) Edwin B. Hendrickson, Herbert W. Hutchinson, and Edward N. Hendrickson; (second row) Harry A. Townsend, Henry D. Mulford, Frederick Hainfeld, and George S. Hastings. (OBHS.)

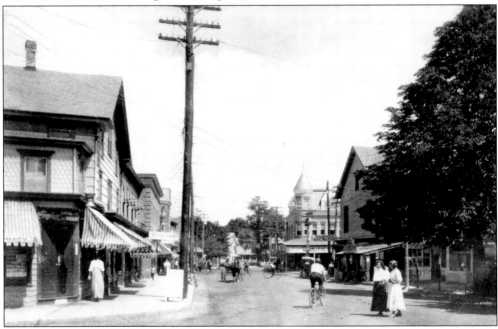

This 1910 photograph of South Street, also on this book's cover, shows Snouder's Drugstore in the left foreground. The building to the left of the large tree was built in 1888 by Samuel VanWyck Fleet. On the first floor of the Fleet building was the meat market owned by Samuel Y. Bayles. South Street was paved a few months after this picture was taken. (OBHS.)

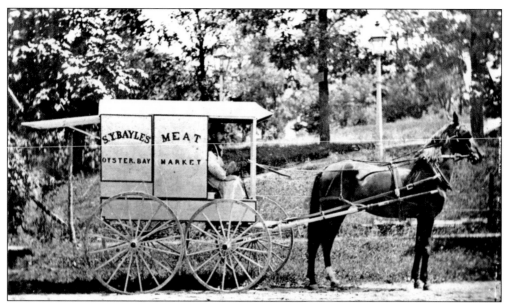

Samuel Y. Bayles had his meat market in the Fleet building and delivered his products to the surrounding area with this horse-drawn wagon. In a narrative to her nieces, Mary Fanny Youngs, who was raised in the Youngs homestead in Oyster Bay Cove, described the foul smells that emanated from the meat wagons. Much of the meat was kept in brine tanks in the wagon and customers reached down deep into the brine to select a choice cut. (OBHS.)

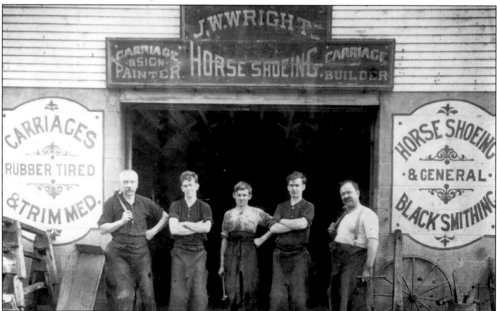

Joseph Warren Wright had his horseshoeing and carriage-building shop on Orchard Street. Part of the building had earlier been the first location of the Methodist church in Oyster Bay, when the church first formed in 1858. In this 1915 image are, from left to right, William Fathers, Alfred Wright, Robert Thiell, Leonard Wright, and Joseph Warren Wright. The blacksmith shop was continued in operation by successive generations of the Wright family up through the 1950s. (JEH.)

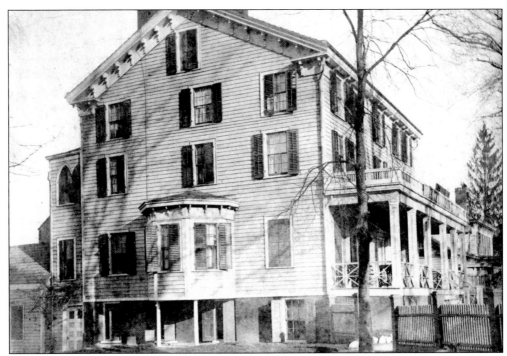

In 1851, Dr. Joel Shew had this building erected on the corner of Maxwell Avenue and West Main Street. Dr. Shew was the leading practitioner of the cold-water treatment that became very popular in the mid-19th century. His practice drew many of the wealthy from New York City to Oyster Bay to partake of his treatments. Dr. Shew died at Oyster Bay in 1855. (OBHS.)

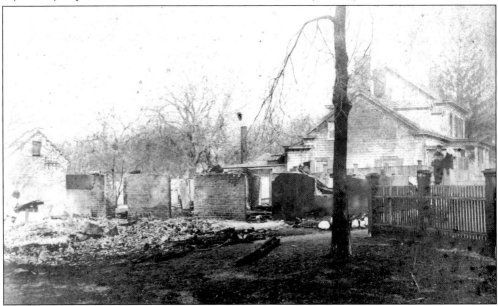

In 1901, Dr Shew's 1851 building on the corner of West Main was the Seawanhaka Hotel, operated by Charles Weeks. Weeks had added a bowling alley in the rear, the first in Oyster Bay, which became a very popular spot. On the evening of March 4, 1901, Charles Weeks lost everything as the entire building was consumed by flames. (OBHS.)

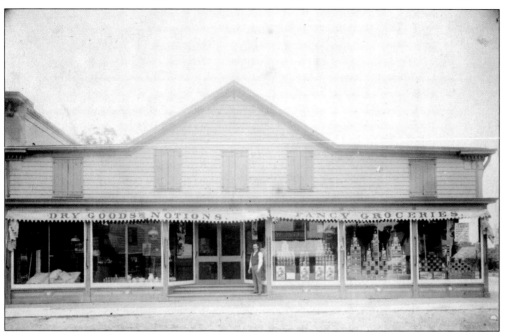

John M. Sammis built this store on South Street in 1846 for his dry goods business. He sold this business in 1868 and bought the lumber and coal business of James Prior at the foot of White Street. A few years later, the dry goods store was bought by Edward A. Hegeman, and it became known as Hegeman's Corner. Edward Hegeman operated the business until 1908. (FRH.)

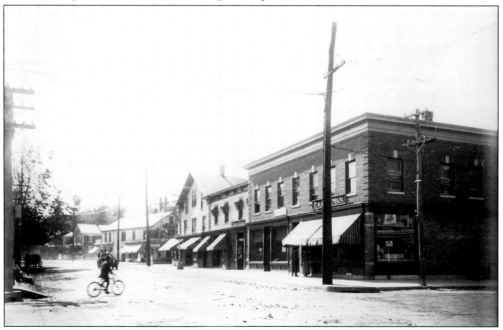

Andrew Snouder acquired the Hegeman corner store property and in 1907 tore down the building that had been built by John Sammis in 1846. In its place, Snouder built a new brick building in which Edward A. Hegeman continued his dry goods business. This photograph was taken in 1908. (JEH.)

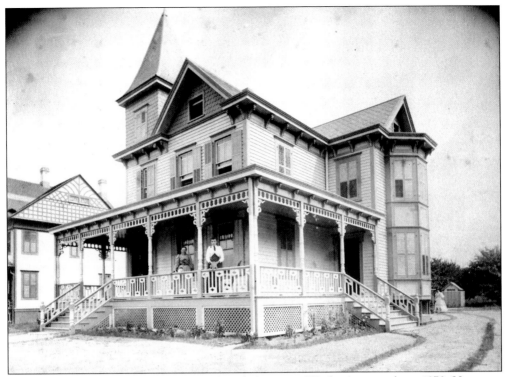

Edward A. Hegeman built this large stick style home on Weeks Avenue about 1870. Hegeman was very active in the community, serving for 25 years as treasurer of the First Presbyterian Church. At the time of his death, he was chairman of the board of directors of the Oyster Bay Trust Company. Hegeman died of a heart attack on the front steps of his home at age 79 in 1937. (FRH.)

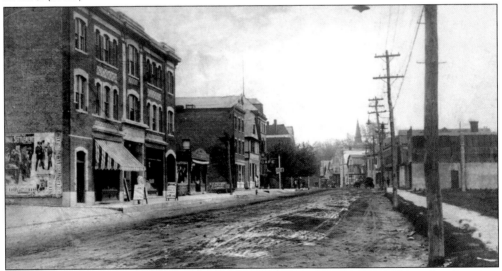

Audrey Avenue was opened in 1890 to give easier access to the new Oyster Bay railroad station, but the street was not paved until many years later. This 1910 view shows the recently completed Lyric Theatre building in the left foreground. Theodore Roosevelt gave several war bond drive speeches in the Lyric Theatre during World War I. (JEH.)

The Oyster Bay Bank building was built on Audrey Avenue in 1893. Theodore Roosevelt's staff had offices on the second floor of the bank during his term as governor of New York. The same room was also used by Roosevelt's executive staff in the summer of 1902, when he was president of the United States. The basement of the building was removed in May 1927 to lower the building and move it forward to align with others on the street. (JEH.)

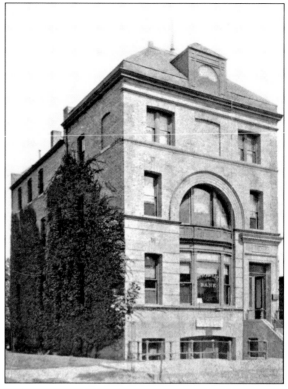

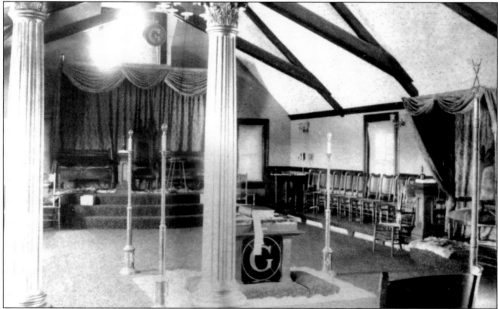

The third floor of the bank building contained the rooms of Matinecock Lodge, Free and Accepted Masons. This photograph shows the lodge room as it looked in 1901, when Theodore Roosevelt became a member. As president, Theodore Roosevelt visited the lodge whenever his schedule permitted, but as the lodge did not meet in the summer, his attendance was usually limited to the first meeting of each September, before he returned to Washington. (JEH.)

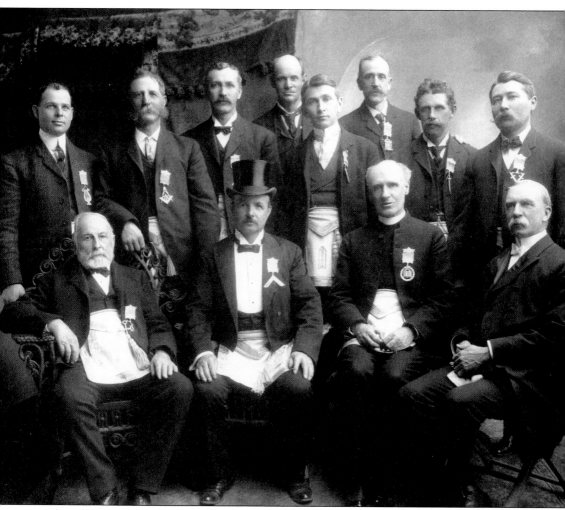

The officers of Matinecock Lodge sat for this formal portrait in 1904. Seen from left to right are (first row) Alfred Ludlam, treasurer; James Duthie, master; Rev. Henry Homer Washburn, chaplain, who was also the rector of Christ Church; and Rev. Alexander Gatherer Russell, who was the pastor at the First Presbyterian Church; (second row) Frank Spicer, George Downing, Edward Waldron, Thomas E. Baldwin, John Bingham, Stephen Bayles, James Buchanan, and Charles Hill. The master of the lodge, James Duthie was the gardener on the estate of Edward Townsend. (JEH.)

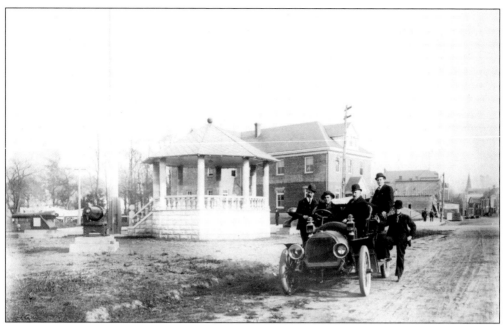

The Townsend family donated a small triangular piece of land on Audrey Avenue to the Town of Oyster Bay, which came to be known as Townsend Park. In 1909, the Town of Oyster Bay contributed $250, which was matched by local residents of the village, to build a bandstand. The Civil War cannon, dedicated by Theodore Roosevelt on June 23, 1903, was moved to the triangle when the bandstand was built. The bandstand was razed in 1939. (JEH.)

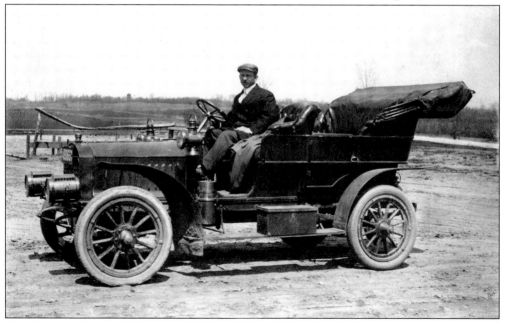

The bandstand at Townsend Park was built by Daniel Kraft, a local contractor, who laid the cornerstone on July 7, 1909. Kraft had a sand mining operation at the corner of Sugar Tom's Lane and supplied sand for many local construction projects. Daniel Kraft built his home on the top of Burtis Avenue and is shown here in his new automobile about 1910. (JEH.)

This view of East Main Street is believed to be from November 1898, when a very heavy early-season snow brought the village to a halt. The snow was so heavy that governor-elect Theodore Roosevelt had to cancel a trip to Boston. In the right foreground is Hawxhurst's Hotel, which was destroyed by fire in 1936. Next to the hotel is Fisher's Hall, where Pres. Theodore Roosevelt voted each year. (OBHS.)

This view of East Main Street is from 1895 and looks toward the west. The building to the right, with the carriage in front, was the store of Richard Sammis. In 1896, the entire block was engulfed in flames, which destroyed Richard Sammis's store, along with several others. The left side of the block was known as Fleet's block after Samuel VanWyck Fleet, who owned most of the properties there. (OBHS.)

In 1910, William Nobman bought the hardware business of Sylvester Holmes in Fleet's block. The part of the building where the hardware store was located was originally the First Presbyterian church, built in 1844. In 1924, Nobman bought Fleet's Hall on the corner of East Main Street and South Street and moved his hardware store to the corner. This photograph of William Nobman in front of his store was taken in 1911. (OBHS.)

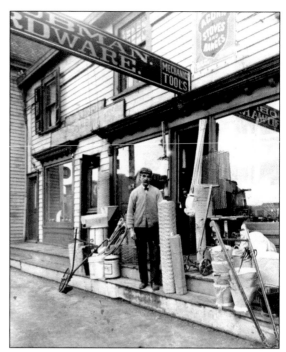

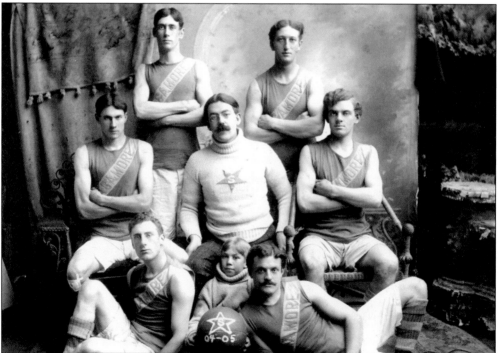

The Sagamore Stars played their basketball games in Fleet's Hall. The 1904–1905 team includes, from left to right, (first row) William Herbert, team mascot Fay Merrill, and Joseph Reynolds; (second row) Willie Mahon, coach Dr. James Hall, and John O'Connor; (third row) Walter Mahon and George Hefner. Willie and Walter Mahon were also very accomplished golfers at the Oyster Bay Golf Club on Berry Hill Road. (OBHS.)

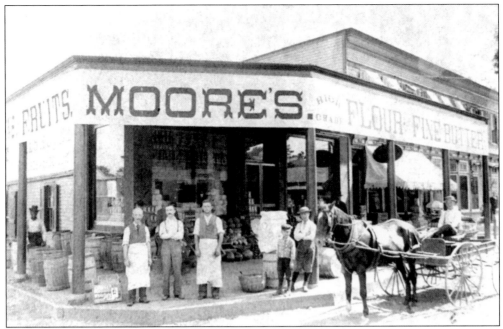

James Moore built his grocery store on the northeast corner of East Main Street and South Street in 1891. The building was originally only one story, but in 1902, he greatly expanded the building with the addition of a second and third floor. In this 1898 photograph, James Augustus Moore stands in front of his store with sons Daniel A. Moore and Sylvester Moore. (JEH.)

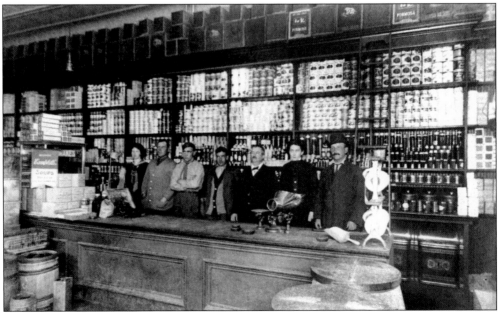

Pres. Theodore Roosevelt moved his executive staff to the second floor of the Moore building in May 1903. Anyone desiring to see Roosevelt would have to get a pass from William Loeb, the presidential secretary, on the second floor. From left to right, included in the Moore staff are Mary Dunn, John Seaman, Arthur Valentine, John Moore, Daniel A. Moore, Mary Bermingham, and John Mills. (JEH.)

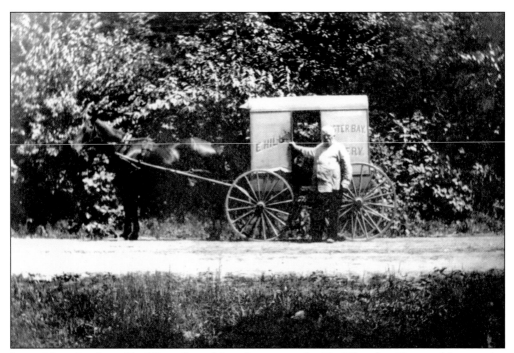

James Moore's enlarged building allowed for other tenants besides Theodore Roosevelt's executive staff. Emil Hill rented part of the rear of the building for his bakery. Hill is shown here with the delivery wagon he used to deliver his bread and other baked goods. (OBHS.)

In a small building behind the Moore Grocery was the printing office of the *Oyster Bay Pilot*. The *Pilot* was Oyster Bay's first newspaper and was founded by Edward N. Townsend, who was a strong advocate of bringing the railroad to Oyster Bay. Townsend used the paper as his personal forum to increase support for the railroad. Standing with his arms folded is Joseph Carl, who was a "printer's devil" for many years with the *Pilot*. (JEH.)

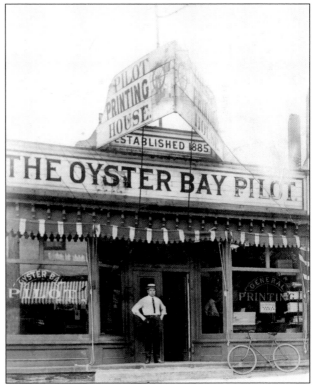

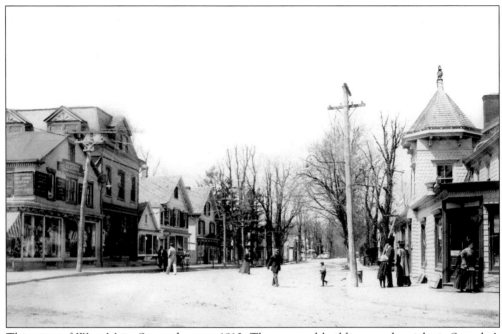

This view of West Main Street dates to 1910. The turreted building on the right is Snouder's Drugstore, which was founded by Abel Conklin in 1880. James Ludlam's 1851 brick building on the left corner was then occupied by Kursman's clothing store. The mansard-roofed building was built as a new post office for Oyster Bay in 1902. (JEH.)

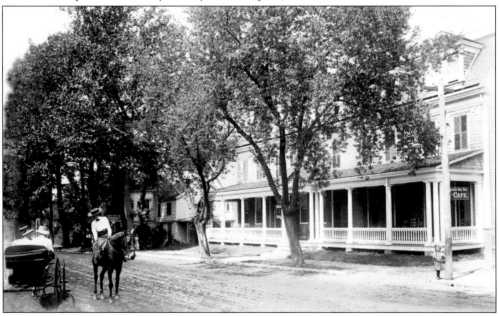

The Townsend Inn was built by Charles DeKay Townsend in 1902 on the former site of Jacob Townsend's house. The building was later acquired by Andrew Snouder, who in turn sold it to Matinecock Lodge in 1924. The many hotel rooms of the inn were removed and the second and third floors were converted into the lodge meeting room. The building was a town of Oyster Bay landmark when it was destroyed by fire in 2003. (JEH.)

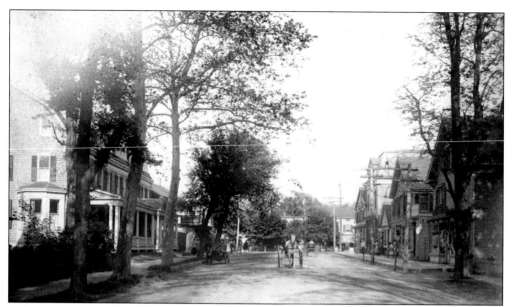

This 1910 view of West Main Street faces toward the east with the Oyster Bay Inn on the left. The buildings on the right are Jacob Prenowitz's clothing store and Gitto's Tailor Shop. Jacob Prenowitz and Gaetano Gitto were both charter members of Matinecock Lodge when it was formed in 1892. The small building between the post office and Gitto's shop is the Ludlam Insurance Agency building that had been moved from its location near the Oyster Bay railroad station. (JEH.)

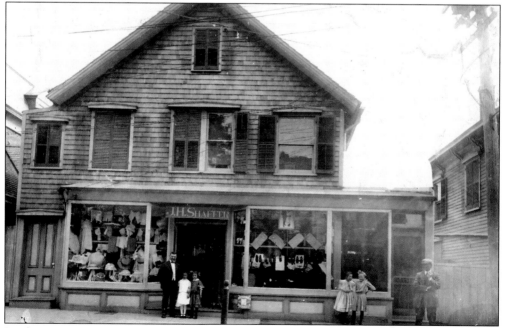

Jacob Prenowitz was born in Russia on July 2, 1857, and came to Oyster Bay as a young man. After many years peddling shoes door-to-door, he established a dry goods and shoe store on West Main Street. In 1912, he sold the store to his son-in-law J. J. Shafter and moved to Brooklyn. This photograph was taken in 1912 shortly after Shafter took possession of the store. (JEH.)

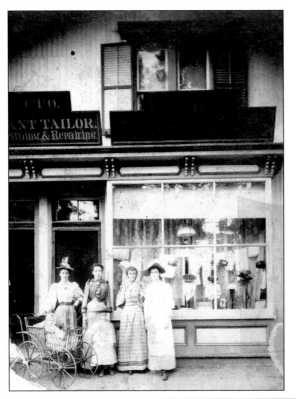

Gaetano Gitto was born in Messina, Italy, on June 5, 1841. This photograph from 1890 shows some of the Wright ladies in front of Gitto's store. The Wright ladies lived in the nearby Seely-Wright house on West Main Street. The baby in the carriage is Leonard Storrs Wright, born on February 8, 1890. He was the son of George Seely Wright and Henrietta King Monilaws. (JEH.)

Nelson Disbrow began publishing the *Oyster Bay Guardian* in 1899. In 1906, he acquired land on West Main Street and built this one-story building for his newspaper and printing business. The press was powered by an engine made by the Titus Machine Shop in Oyster Bay and was known as an Oyster Bay Engine. (JEH.)

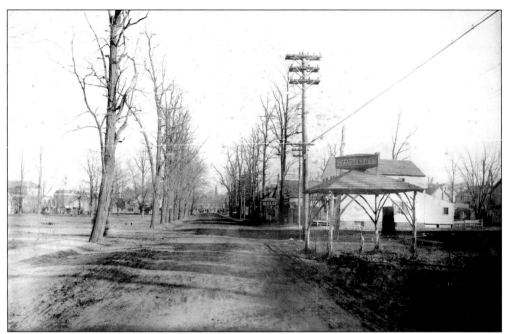

This 1911 view of the corner of Spring Street and West Main Street shows the stagecoach stop in the right foreground. The sign on the top of the stage stop refers to the Octagon Hotel, where passengers were regularly picked up. The open field to the left of the locust trees was known as Townsend's Cow Lot, where the early baseball teams played their games. (JEH.)

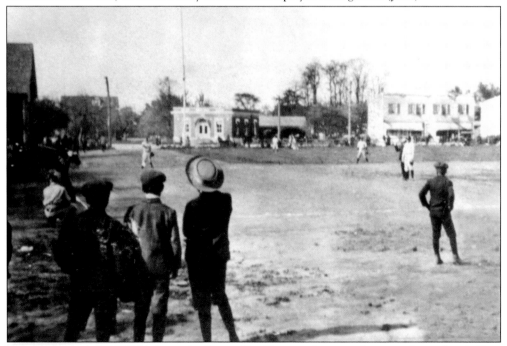

This photograph from 1904 shows the Oyster Bay Nine, as they were known, playing baseball on Townsend's Cow Lot. In the background is the one-story Oyster Bay Town Clerk's Office. The building in the right background was Downing's store and was destroyed by fire in 1907. (JEH.)

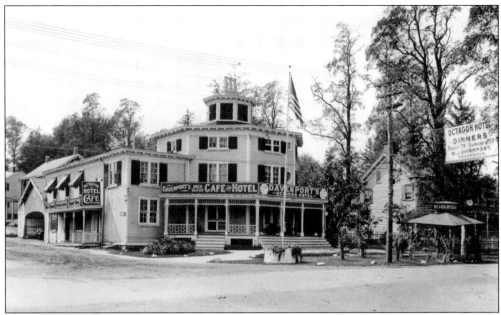

The Octagon Hotel, built on the corner of West Main Street and Spring Street in 1851 by Luther Jackson, became the fanciest place to stay in the village. When Theodore Roosevelt spent his first summer in Oyster Bay as governor in 1899, he selected the Octagon Hotel as the place for his executive staff office. The single room proved too small, however, and the staff moved to the Oyster Bay Bank building the following year. (JEH.)

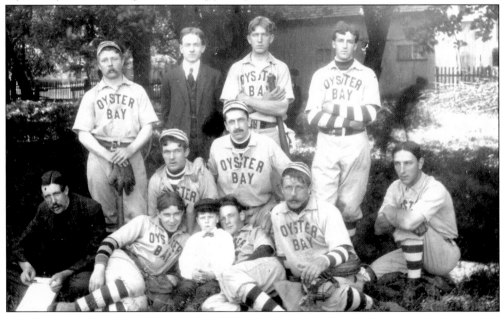

The 1904 Oyster Bay Nine baseball team poses for a team photograph. Seen are, from left to right, (first row) Ed Knapp, Danny Murray, an unidentified team mascot, Red Cody, James H. Vernon, and Fred Vernon; (second row) Jim Thompson and James "Pin" Earle; (third row) John Hill, Chester Robinson, Scotty Thompson, and Lee Townsend. The 1904 season was the first year that Oyster Bay and East Norwich played as a combined team. (OBHS.)

Harold Hathaway Weeks was raised in the family home on the corner of West Main Street and Lexington Avenue. Weeks became a star athlete at Columbia University and was selected All-America. Yale University had the most powerful football team in the country in 1899 when Harold Weeks, as a freshman, scored the only points in the game by running 50 yards for a touchdown in the second half. (OBHS.)

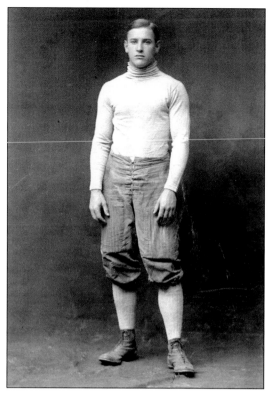

Dr. Peter Young Frye maintained his medical practice in a small building on South Street. Frye was born in Deerfield, New Hampshire, in 1817 and came to Oyster Bay in 1856. He was very loved and admired in the community and served many years as a trustee and elder at the First Presbyterian Church. Dr. Frye died on October 9, 1897, and was buried in Youngs Memorial Cemetery in Oyster Bay Cove. (OBHS.)

Anna and Thomas Waverly Wright were born in the Seely-Wright homestead on West Main Street. Thomas Waverly Wright was born on September 20, 1888, and Anna was born on October 26, 1889. They were children of Joseph Warren Wright and Mary White Smith. Anna married John Bodine Doughty of Brooklyn on January 1, 1914. As an adult, Waverly Wright became an active member of the Atlantic Steamer Fire Company and usually drove the company truck in the Oyster Bay parades. (OBHS.)

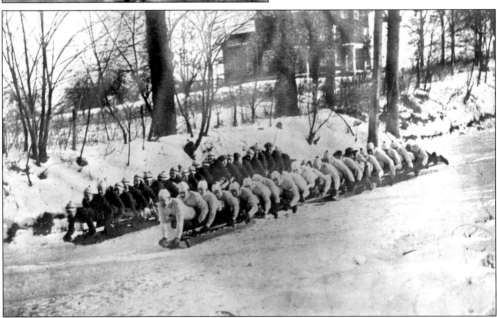

Bobsled racing was a favorite winter activity around the beginning of the 20th century. Races were held in various communities of the North Shore including Oyster Bay, Locust Valley, East Norwich, and Huntington. In this photograph, the Bayville 1911 team is in dark sweaters and the Oyster Bay Man O War team is in white sweaters. The Man O War was built in the Wright Blacksmith shop in Oyster Bay. (OBHS.)

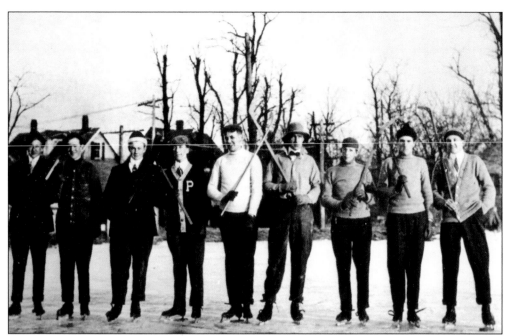

Ice hockey was played as a pickup activity at various sites including Brown's Pond in East Norwich, Beaver Dam in Mill Neck, and at the millpond in Oyster Bay. This photograph was taken about 1920 at the millpond in Oyster Bay. Unfortunately the names of the players have been lost. (OBHS.)

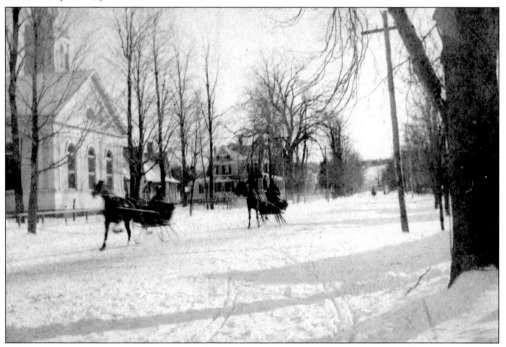

Getting around in the wintertime had both its difficulties and its pleasures. These two sleighs are shown racing down South Street in 1900. To the left are the Methodist church and the Burtis-Weeks house. (OBHS.)

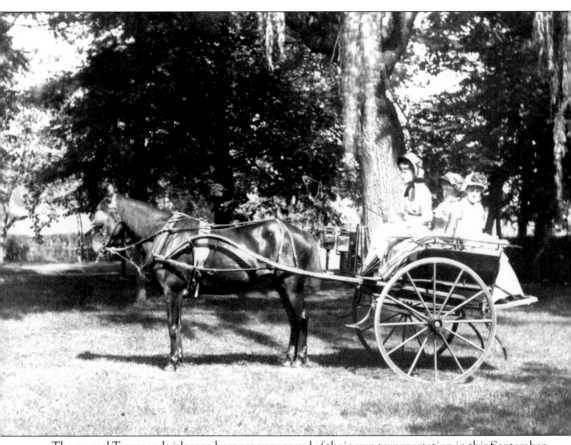

The several Townsend girls seen here are very proud of their own transportation in this September 1881 photograph. Although pulled by a pony, it was called a dogcart. (OBHS.)

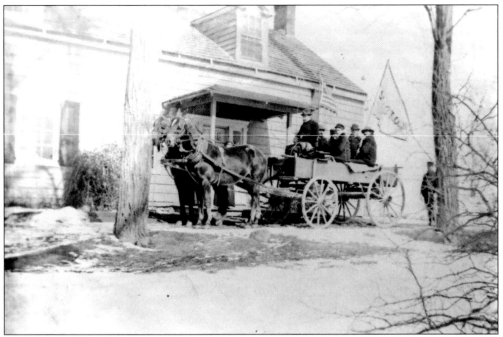

The Sciotto Gun Club had its shooting grounds on the Moyses family farm on Berry Hill Road. In this 1898 photograph, the club members proudly hold their club flag as they pose in front of the Moyses farmhouse on the way to one of their shooting competitions. (JEH.)

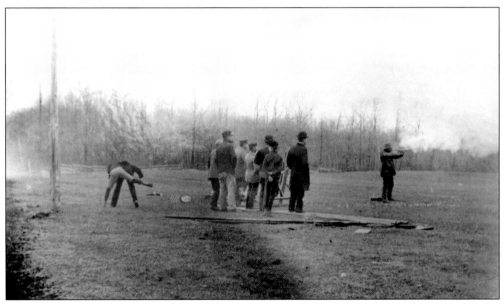

Members of the Sciotto Gun Club are shown shooting at the Moyses family farm in 1898; the Moyses family also leased out part of their grounds to the Oyster Bay Golf Club. Among the members of the Oyster Bay Golf Club were Louise Tiffany (wife of Louis Comfort Tiffany), Colgate Hoyt, Gerard Beekman, and Theodore Roosevelt. The famous golf course designer Devereaux Emmett was chairman of the greens committee of the Oyster Bay Golf Club and probably was also its designer. (JEH.)

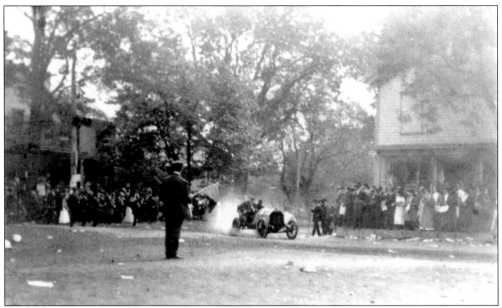

William K. Vanderbilt Jr. was an avid motorist and established the Vanderbilt Cup Races in 1904. In 1905, he expanded the course to include East Norwich. This photograph shows car No. 8 making the turn at the corner of Oyster Bay Road and North Hempstead Turnpike on October 6, 1906. The crowd along the entire 29.7 mile course was estimated at over 400,000. (JEH.)

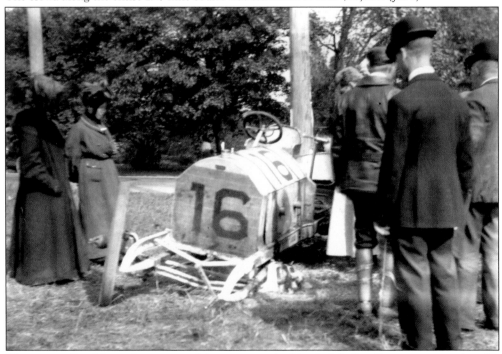

The turn at East Norwich was one of the worst on the Vanderbilt Cup Race course, and in the 1906 race, a car went into the crowd killing one man and injuring young Harrold Baldwin. Due to public outcry, there was no race in 1907. Shown here is car No. 16, which crashed in the 1906 race. (NCM.)

Three

THEODORE ROOSEVELT

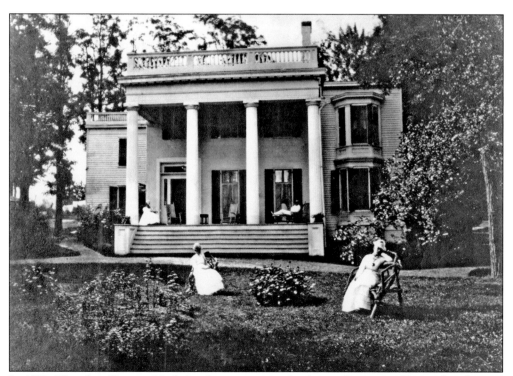

In 1874, Theodore Roosevelt's father began renting this house, known as Tranquility, located on the south side of Cove Road. The house was built in 1837 by Gabriel Irving, a nephew of the author Washington Irving, on land that Gabriel's father, John T. Irving, had bought in 1835. Sitting on the porch are Theodore Roosevelt's mother and father while his sister Corinne and friend Edith Kermit Carow rest on chairs in the foreground. (TRC.)

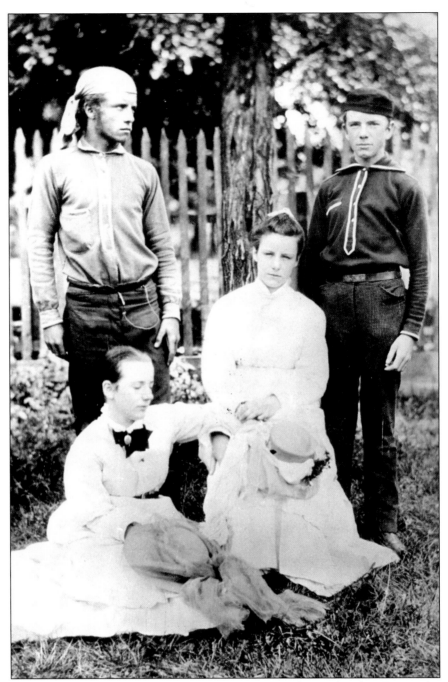

This 1875 photograph, taken at Tranquility on Oyster Bay, shows Theodore Roosevelt on the left and his brother Elliott on the right. Elliott was born in New York City on February 28, 1860, and married Anna Rebecca Hall. Elliott and Anna were the parents of Eleanor Roosevelt, who married her fifth cousin Franklin Delano Roosevelt in New York City on March 17, 1905. Seated in front are Corinne Roosevelt and Theodore Roosevelt's future second wife, Edith Kermit Carow, in the chair. Both the Roosevelt and Carow families spent the summers at Oyster Bay and also lived near each other in New York City. (TRC.)

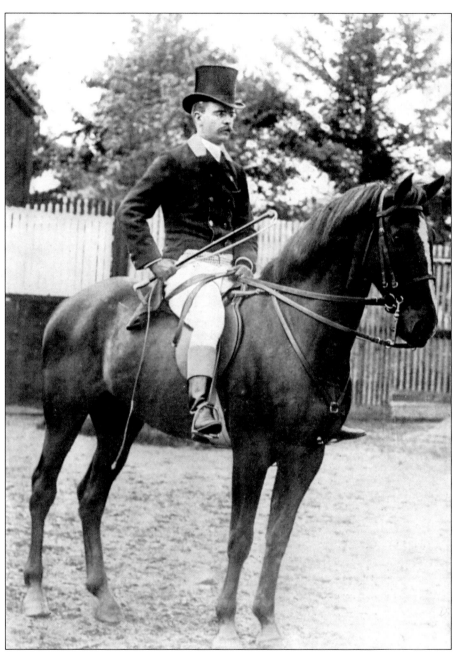

After losing much of his inheritance in his financially failed ranching forays in the badlands, Theodore Roosevelt returned to Oyster Bay. He joined the Seawanhaka Corinthian Yacht Club and the Meadowbrook Hunt Club. In October 1885, Theodore hosted the Meadowbrook Hunt Club at a foxhunt at Sagamore Hill. During the hunt he broke his arm after jumping over a stone wall and falling off his horse. In September 1886, he lost the silver cup sailing race in his yacht *Mist* to Edward Townsend's yacht *Dodo*. A few years later, Roosevelt joined the newly formed Oyster Bay Golf Club. In 1888, Theodore Roosevelt formed a polo team at Oyster Bay with Frank Underhill; among the teams they played was his brother Elliott's Hempstead polo team. (SAHI.)

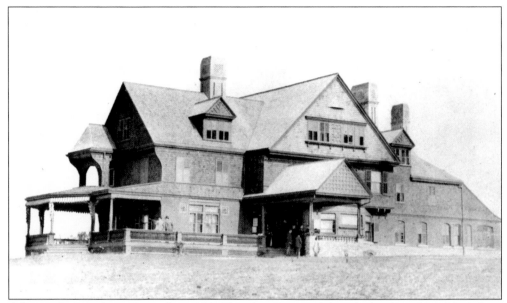

After graduating from Harvard in 1880, Theodore Roosevelt bought land on Cove Neck from the Youngs family. Theodore and his wife Alice Hathaway Lee planned to call their home on Cove Neck Leeholm. Two weeks after the tragic deaths of his first wife, Alice Lee Roosevelt, and his mother on February 14, 1884, Theodore Roosevelt signed a $16,975 contract for the construction of his home but changed the name to Sagamore Hill. This photograph shows Sagamore Hill shortly after its completion in 1885. (TRC.)

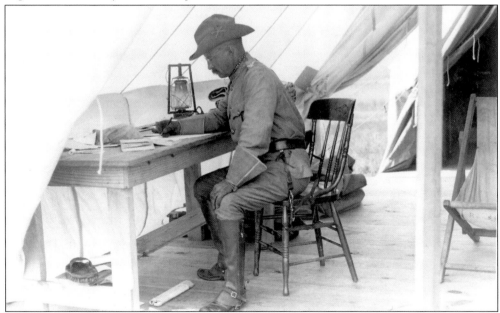

In 1898, Theodore Roosevelt became a national hero through his actions in Cuba during the Spanish-American War. Rev. George Roe VandeWater, the former rector of Christ Church in Oyster Bay, was with Roosevelt in Cuba. Reverend VandeWater had left his pastorate in New York City to become chaplain of the 71st New York Volunteers, the same unit that Theodore Roosevelt had served with in 1880 when he attained the rank of captain. (TRC.)

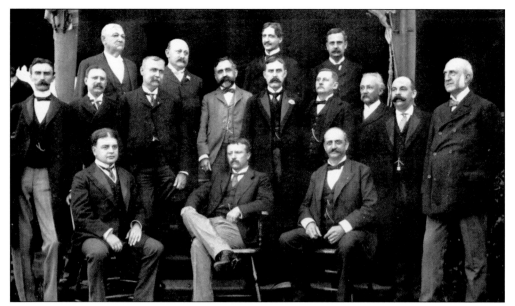

Roosevelt was extremely popular following the Spanish-American War and was selected to be the candidate for governor of New York. Roosevelt chose his neighbor and friend Judge William Jones Youngs to manage his campaign. Judge Youngs lived in the Youngs family homestead located just a short way down the road from Sagamore Hill. This photograph was taken on October 4, 1898, and shows Theodore Roosevelt with the nomination notification committee at Sagamore Hill. (SAHI.)

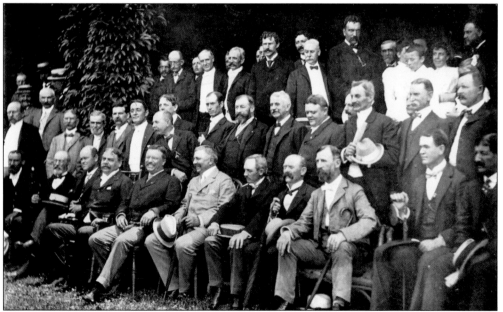

Theodore Roosevelt was elected governor of New York in November 1898. Less than two years later, he was nominated to be the running mate of Pres. William McKinley. This photograph was taken at Sagamore Hill on July 14, 1900, and shows Roosevelt seated in the front row with a broad toothy smile. He commented at the time that he felt he was being put out to pasture and that his political career was then over. (SAHI.)

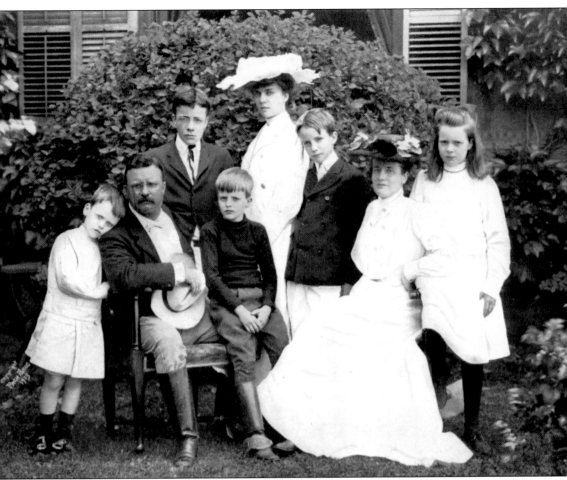

The Roosevelt family greatly looked forward to returning to Oyster Bay each summer. Edith generally arrived with the children in May or June and President Roosevelt arrived in June or July, depending on what his schedule allowed. This 1902 photograph of the family at Sagamore Hill shows, from left to right, Quentin, President Roosevelt, Theodore Jr., Archie, Alice, Kermit, Edith, and Ethel. (SAHI.)

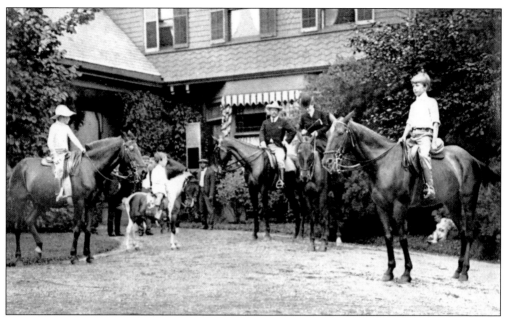

During the summers at Oyster Bay, the Roosevelt family engaged in many of their favorite pastimes, including horseback riding. All of the Roosevelt's were excellent riders. Roosevelt would also make overnight camping trips with some of the boys. In 1906, Roosevelt eluded the Secret Service men assigned to protect him and went with the boys aboard the presidential yacht *Sylph* to camp at Lloyd's Neck. (SAHI.)

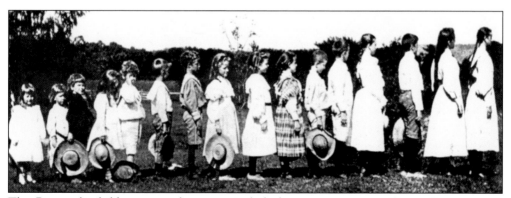

The Roosevelt children were always particularly happy to return to Oyster Bay to renew friendships with local children and to see their very many cousins who lived in Oyster Bay. This photograph shows the 16 Roosevelt cousins that lived very near Sagamore Hill. (SAHI.)

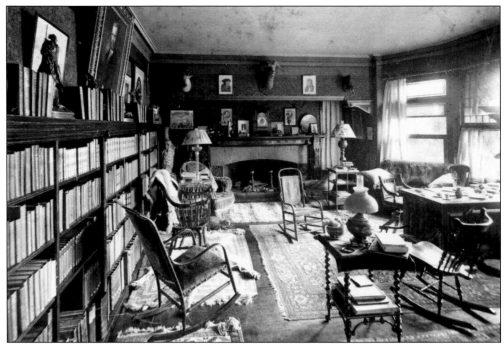

While the Roosevelt children spent their summers at play in Oyster Bay, Pres. Theodore Roosevelt attended to the duties of his office. Roosevelt greeted visiting heads of state and government officials in his office at Sagamore Hill. This photograph shows his office at Sagamore Hill as it appeared during the presidential summers 1902 through 1908. (SAHI.)

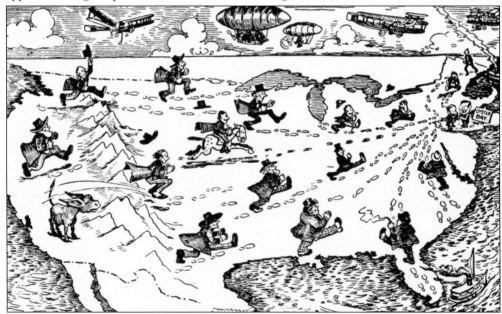

Although several presidents before Roosevelt had spent summer vacations away from the White House, Roosevelt was the first to actually relocate the executive branch of the government for the whole summer. This cartoon from a New York City newspaper shows all roads leading to Oyster Bay. (SAHI.)

In 1903, President Roosevelt was invited to participate in the celebration of the 250th anniversary of Oyster Bay's first purchase. Roosevelt arrived by special train at about 3:00 in the afternoon. This picture appeared in the 1904 publication *Our Patriotic President* and shows President Roosevelt on June 27, 1903, walking the short distance from the Oyster Bay railroad station to the Oyster Bay Town Clerk's Office on Audrey Avenue to speak at the celebration. (SAHI.)

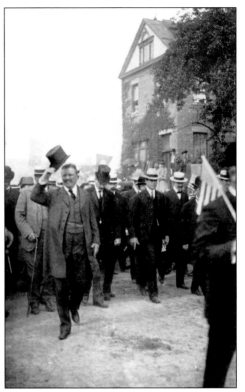

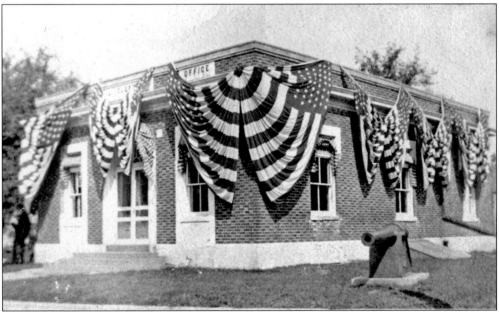

On June 27, 1903, Pres. Theodore Roosevelt dedicated this cannon at the Oyster Bay Town Clerk's Office. The cannon was from the Civil War ship USS *R. R. Cuyler*, which pursued the CSS *Florida* in May 1862. In a strange twist, the *Florida* was the first of several ships that Theodore Roosevelt's uncle James Dunwody Bulloch had acquired from Britain for the Confederate navy. The cannon was later moved to Townsend Park. (JEH.)

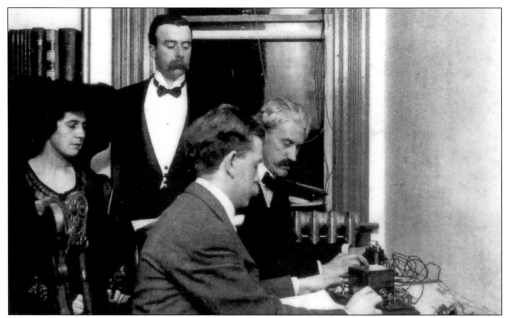

On July 4, 1903, the first "Round the World" telegram was sent from the Moore Building in Oyster Bay when Pres. Theodore Roosevelt gave the signal by telephone from Sagamore Hill. The sending of the telegram had been delayed until late in the day because of Roosevelt's appearance in the nearby village of Huntington to speak at that village's 250th anniversary celebration. Standing with the bow tie is Clarence MacKay, owner of the Pacific Telegraph Company. (TRA.)

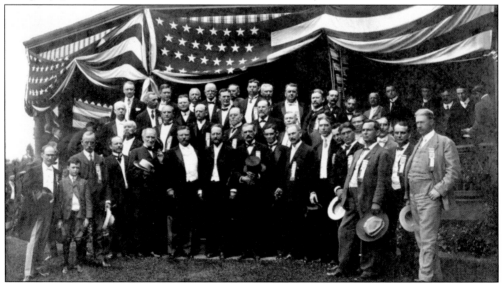

On July 27, 1904, Pres. Theodore Roosevelt was notified at Sagamore Hill of his nomination to run for a full term as president. Roosevelt had great concern about his ability to be elected in his own right, but he won by a huge margin. Earlier that month, Roosevelt had arrived in Oyster Bay for the Fourth of July celebration. The students of the Cove School, where some of the Roosevelt children had been students, turned out in full force and each held flags as the president passed by. (OBHS.)

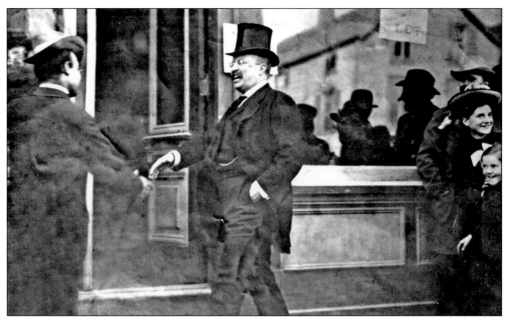

On the evening of November 7, 1904, President Roosevelt left Washington by special train for Oyster Bay. Roosevelt returned to Oyster Bay every year on Election Day to vote. In this photograph he is shown greeting local music store owner Adolph Groebl in front of Fisher's Hall on East Main Street. The little girl with the hat in the right of the picture is Gertrude Fisher, daughter of John Fisher. (TRA.)

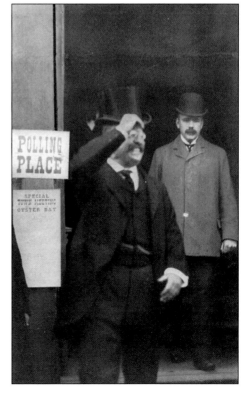

Roosevelt exhibits his usual toothy smile as he exits Fisher's Hall on November 8, 1904. Although Roosevelt returned to Oyster Bay each November to vote, he seldom stayed more than an hour. He was usually in and out of the polling place in a minute or two. He would then take a carriage ride up to Sagamore Hill to check on the place before returning to the station to board his special train. (SAHI.)

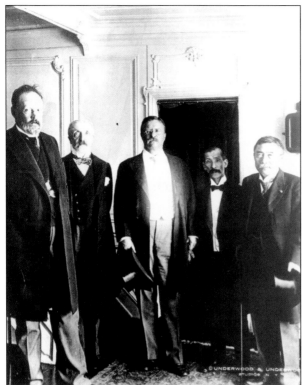

In August 1905, Pres. Theodore Roosevelt called the delegations of Japan and Russia to Oyster Bay to discuss the Russo-Japanese War. Roosevelt first met separately with each delegation at Sagamore Hill. He then brought the two parties together aboard the presidential yacht *Mayflower*. This photograph was taken aboard the *Mayflower* as it was anchored in Oyster Bay in August 1905. (TRC.)

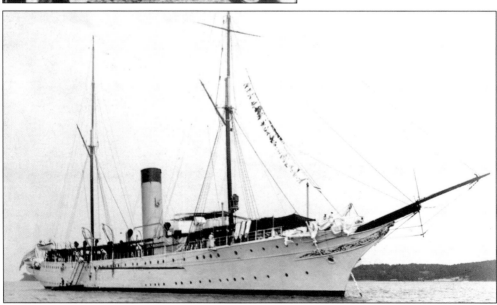

The USS *Mayflower*, at 2,790 tons displacement, was the largest of the three presidential yachts. Pres. Theodore Roosevelt usually reserved the *Mayflower* for special occasions, like the visiting Russian and Japanese delegations. After meeting aboard the *Mayflower*, Roosevelt sent the two delegations up to Portsmouth, New Hampshire, to work out a settlement to the war. For his actions in bringing about a settlement of the Russo-Japanese War, President Roosevelt was awarded the Nobel Peace Prize in 1906. (RYC.)

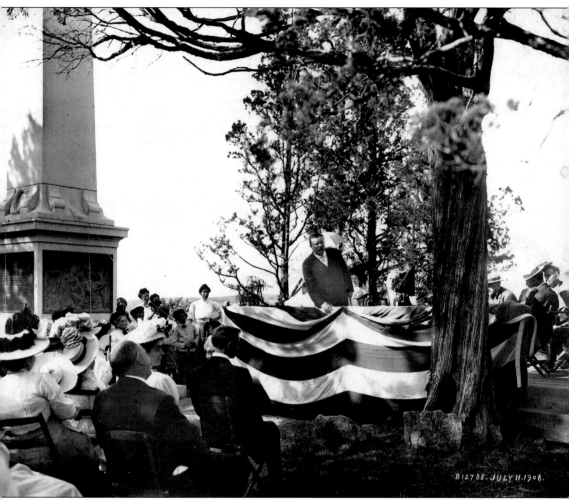

On July 4, 1906, Roosevelt gave his annual presidential speech in Oyster Bay at Robert Jordan's Locust Grove off Ivy Street. He was a frequent speaker at numerous local activities, including the cornerstone for the library, the cornerstone for the high school, and, in this photograph, at the dedication of the monument to Capt. John Underhill on July 11, 1908. Roosevelt also spoke from the pulpit of most of the churches in Oyster Bay. In his August 16, 1903, speech to the Holy Name Society, Roosevelt made a point of mentioning that in 1895 he had been the very first contributor to the building fund for the new St. Dominic Roman Catholic Church at Oyster Bay. (USA.)

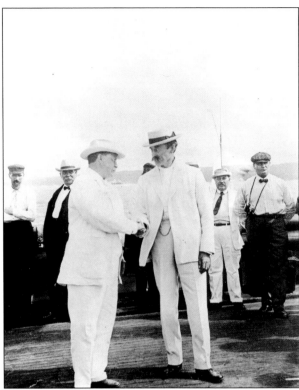

Commodore Robert Peary had named his arctic exploration vessel the *Roosevelt* and on July 6, 1908, Peary brought his ship to Oyster Bay. Peary was on his way to the exploration that resulted in his reaching the North Pole. This photograph was taken aboard the *Roosevelt* in Oyster Bay Harbor on July 6, 1908. (TRC.)

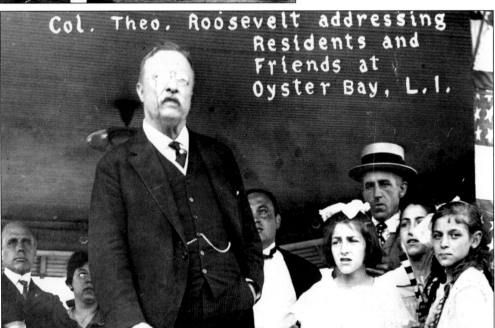

Col. Theo. Roosevelt addressing Residents and Friends at Oyster Bay, L.I.

Theodore Roosevelt was known by his Oyster Bay neighbors as "the Colonel," referring to his Spanish-American War rank. He continued to be a very popular local speaker in Oyster Bay long after the years of his presidency. This postcard image shows Colonel Roosevelt addressing the people of the village from the bandstand at Townsend Park on July 4, 1916. (OBHS.)

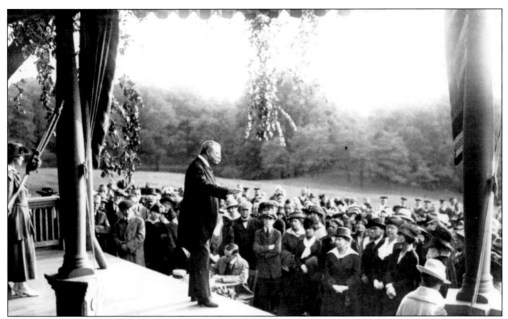

During World War I, Colonel Roosevelt spoke from the stage at the Lyric Theatre on Audrey Avenue in support of the local war bond drive. He also frequently spoke from the porch at Sagamore Hill to groups of Boy Scouts, which he supported enthusiastically, and to women's suffragists. This photograph shows Colonel Roosevelt speaking from the porch at Sagamore Hill in 1917. (TRC.)

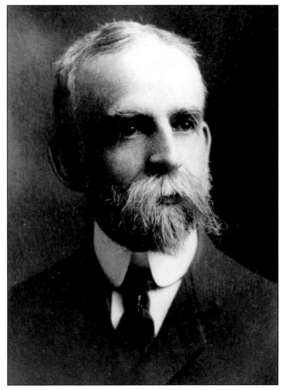

On the morning of January 5, 1919, local barber John Gerardi came up to Sagamore Hill to give Col. Theodore Roosevelt his daily shave. Later, while sitting and talking with his wife Edith, Roosevelt told her, "I wonder if you will ever know how much I love Sagamore Hill." On the evening of January 5, 1919, Roosevelt complained that he was not feeling well, and Edith called the family physician. Dr. George Washington Faller (seen here) gave Roosevelt some medication, but Roosevelt died in his sleep early on the morning of January 6, 1919. (JEH.)

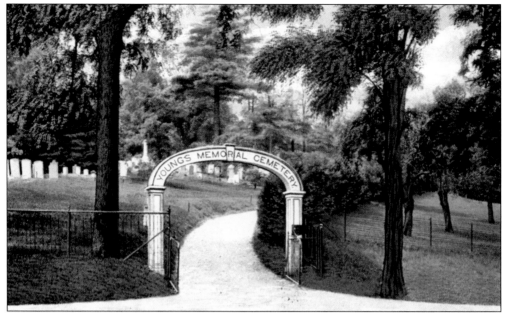

On January 8, 1919, a funeral service was held for Theodore Roosevelt at Christ Church in Oyster Bay. He was buried at Youngs Memorial Cemetery in Oyster Bay Cove, a short distance from his beloved Sagamore Hill. Roosevelt had expressed his desire to his personal secretary William Jones Youngs to be buried in Oyster Bay, and Billy Youngs offered Roosevelt a plot in his family's cemetery. (JEH.)

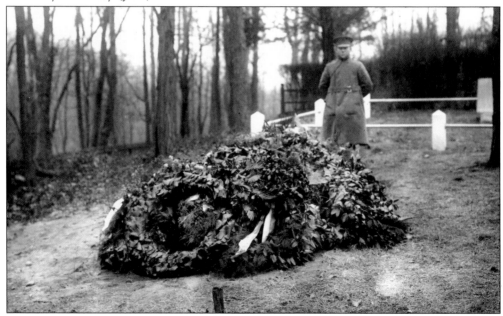

Former president William Howard Taft was seen to be weeping profusely as he walked down the hill from Theodore Roosevelt's grave. Taft and Roosevelt had ended their political feud only a few months earlier. For weeks after Roosevelt's burial, a military detachment, commanded by Lt. C. T. Reynolds, guarded the grave of Theodore Roosevelt until suitable fences and gates could be installed. (TRA.)

Four

GOVERNMENT AND PUBLIC SERVICES

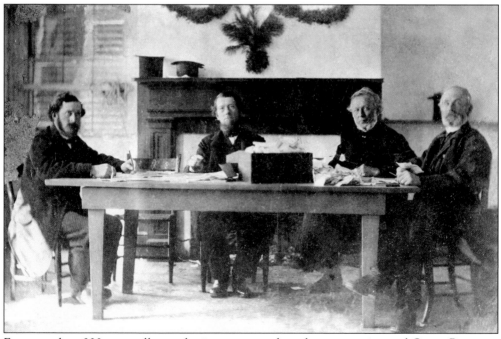

For more than 200 years, all town business was conducted at two semiannual Oyster Bay town meetings. This photograph, taken on April 4, 1866, shows the town board of canvassers, as the town board was then called, meeting inside the hotel at East Norwich. From left to right are Walter Franklin, justice of the peace; John N. Remsen, town clerk; John Rushmore, justice of the peace; and Samuel Frost, justice of the peace. (JEH.)

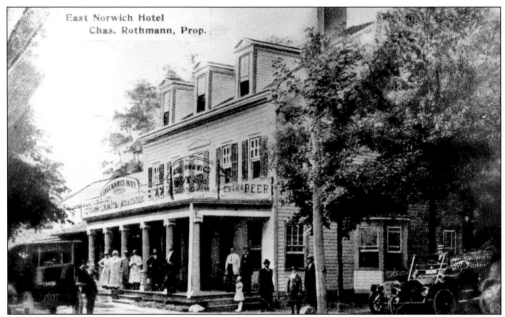

The semiannual Oyster Bay town meetings were held for more than a century at the hotel in East Norwich. All matters were voted upon in a meeting in the street outside of the hotel, which is shown here when Charles Rothmann owned it in 1907. The meetings were festive affairs and usually had over 800 attendees. Some sources date the age of the hotel building as before the Revolutionary War. (JEH.)

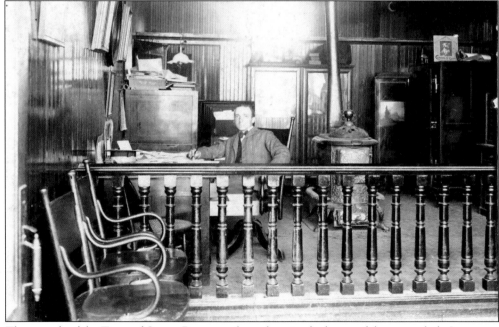

The records of the Town of Oyster Bay were always kept in the home of the town clerk. It was not until 1887 that the first office was built for the town clerk and the records received a permanent, safe home, although in 1901, the basement flooded causing damage to many of the old records. This 1897 photograph shows town clerk James L. Long in his office on South Street. (JEH.)

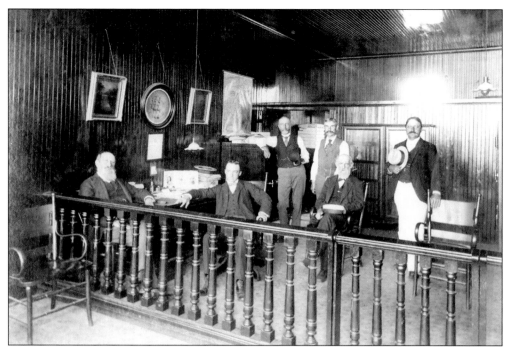

This 1897 photograph was taken in the summer when the potbelly stove had been removed. From left to right are (seated) Townsend D. Cock; James L. Long, town clerk; and Walter Franklin; (standing) William L. Jones; Arnold P. Hertz; and Maurice Townsend, the Democratic Party leader in the village. Maurice Townsend was also the director of the Oyster Bay Band, which played for Pres. Theodore Roosevelt's arrivals and speeches. (JEH.)

Following the flood of the town clerk's office in 1901, the Town of Oyster Bay acquired land on Audrey Avenue for a new town clerk's office. The cannon to the right of the building was dedicated by Pres. Theodore Roosevelt on June 27, 1903. When dedicating the cannon, Roosevelt spoke to the people of the village from the small stoop of the town clerk's office. (JEH.)

Town business grew dramatically in the early part of the 20th century. A second floor was added to the town clerk's office, plus a two-story extension to the rear in 1909. In 1911, the town records dating back to the 1653 first purchase deed were almost lost when a prisoner in the basement jail set fire to his mattress. While the fire was not great the resulting water used to put it out almost destroyed the early records. (JEH.)

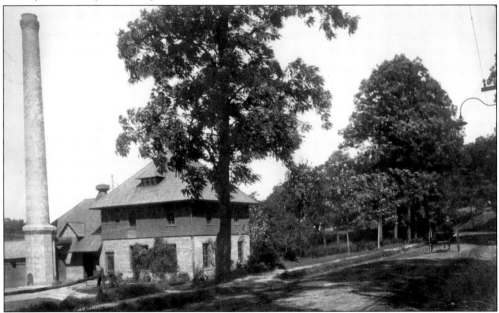

Public water was a new thing in Oyster Bay at the beginning of the 20th century. This 1906 photograph shows the Oyster Bay Water Company building on Poverty Hollow Road (now called Mill River Road). The large stack is for the steam generator that powered the pump. The pump fed a 220,000-gallon standpipe on the other side of the road. More than eight miles of pipe were laid in the village along with 100 fire hydrants. (JEH.)

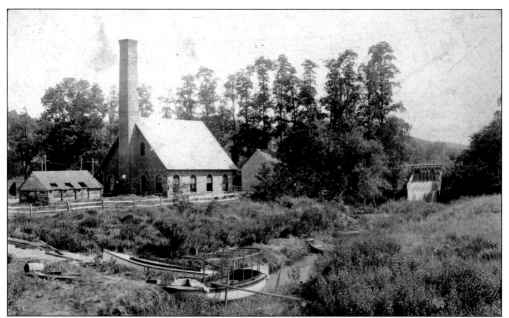

The building with the stack is the Oyster Bay Electric Company. The company was formed in 1891 when representatives of the Edison Electric Light Company interested local businessmen in the idea. This was the first electric-generating facility in Nassau County when it was put in operation in 1892 using waterpower from the millpond. The electricity generated was direct current and could only provide lighting for a small number of lights in the village. (RYC.)

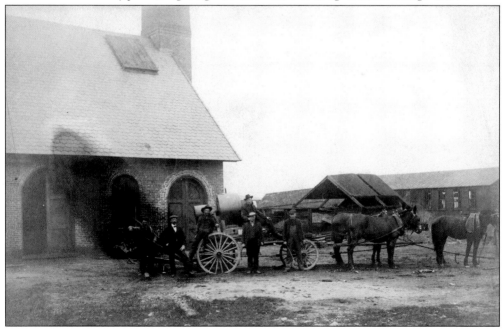

Within two years of beginning operations, the hydroelectric generators were replaced with a small diesel generator. In 1897, a larger generator was installed and the system was converted to alternating current. This photograph from 1897 shows some of the new equipment arriving for the conversion. (RYC.)

Daniel Dykeman Smith was the contractor who built the Oyster Bay Electric Company building. Smith is shown here with his family at their home on the corner of Bayside Avenue in 1896. On the left of the photograph is one of the original arc lights supplied by the direct current from the plant. In 1897, the arc lights were replaced throughout the village with incandescent lights. (RYC.)

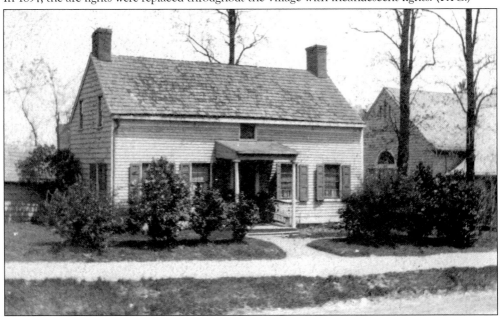

This small house on East Main Street was built in the 1600s by Simon Cooper. It was occupied by many generations of the Minor family. In 1802, Ezra Minor was appointed postmaster for Oyster Bay and the building thus became Oyster Bay's first post office. It continued as the post office for almost 100 years, until the office moved first to Fleet's Block and then to a new building on West Main Street in 1902. (OBHS.)

Annie Larrabee was the postmaster for Oyster Bay from May 14, 1896, to January 19, 1911. She was born in the family home on Larrabee Avenue and attended the local schools. It was during her term as postmaster that free delivery started in 1906 with Larrabee hiring Alfred Mills as a letter carrier. Home delivery resulted in people in the village having to place numbers on their houses so that mail could be properly delivered. (OBHS.)

In 1918, a new post office was built at 10 Audrey Avenue. This 1918 photograph shows it being readied for its grand opening. The building was owned by Thomas H. O'Keefe, the Democratic Party leader in the town of Oyster Bay. O'Keefe bought the *Oyster Bay Pilot* newspaper that same year and carried on a feud with Nelson Disbrow and his *Oyster Bay Guardian*. The feud ended when O'Keefe died in 1921. (JEH.)

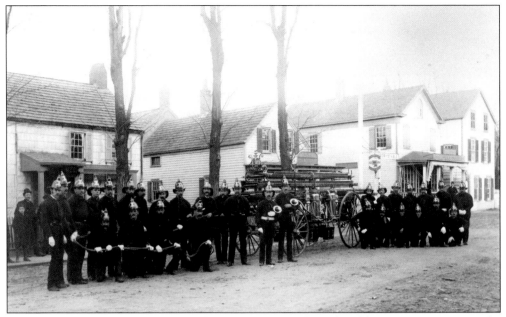

Oyster Bay's first fire company was the Protection Hook and Ladder Company No. 1. The company posed for this photograph on East Main Street in 1888, shortly after taking delivery of a new hook-and-ladder apparatus. The first building on the left is a clothing store followed by a tavern and Richard Sammis's general store. Between the tavern and the general store can be seen the village liberty pole. (OBFC.)

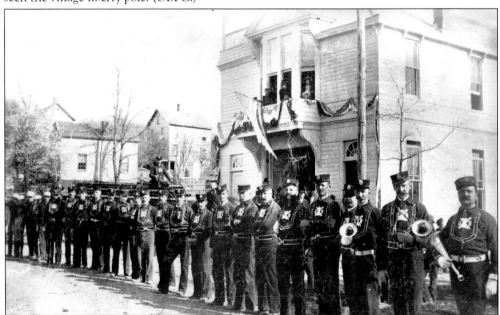

The Protection Hook and Ladder Company changed its name to the Oyster Bay Fire Company No. 1 on December 24, 1890. On April 26, 1894, the company dedicated its new truck house on Bayles Hill (Summit Street) with elaborate celebrations. Equipment was kept on the first floor while the second floor had a large room that was used by many community organizations for meetings, dinners, and other special occasions. (OBFC.)

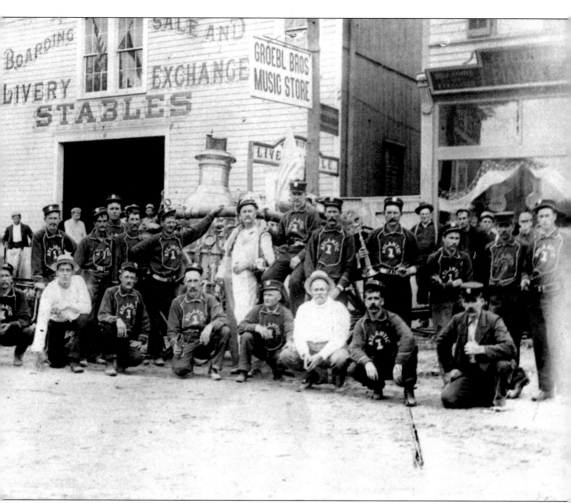

On September 9, 1890, Chemical Engine Company No. 1 was chartered. This was followed by the Atlantic Hose Company in 1891. In 1896, these two companies combined to form the Atlantic Steamer Company No. 1. The name steamer came from the new Silsby size 5, village steamer. In this 1895 photograph, the members pose with their new steamer in front of Sniffen's Livery Stable on East Main Street. The Silsby steamer greatly expanded firefighting capability in Oyster Bay. It could deliver 300 gallons per minute at 120 pounds per square inch of pressure from a cold start in only eight minutes. On June 26, 1895, a demonstration was given to the community on Audrey Avenue. The Silsby drafted water from Anthony's Brook on East Main Street and pumped it high over the new Oyster Bay Bank building. (JEH.)

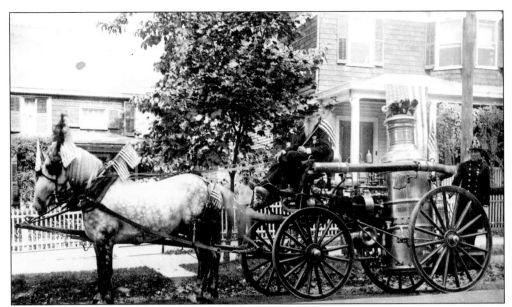

The Silsby steamer remained in valued service to the community for over 20 years but with the development of motorized fire apparatus, the Silsby was relegated to ceremonial parade duty. In this photograph taken on East Main Street on July 4, 1916, Harry Perrine holds the reins while William Heffner Sr. proudly carries the flag. On the back in the fireman's station is William Lent. The Silsby was sold in 1919 to Waldron Bayles, who put it to good use at the oyster dock to wash incoming loads of oysters. (OBHS.)

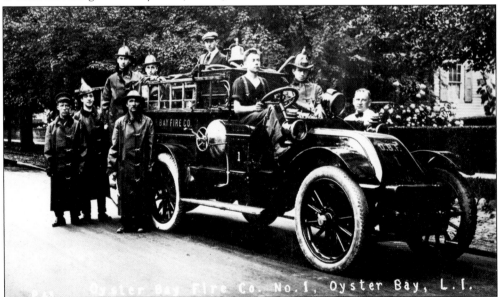

Oyster Bay came into the motor age of firefighting when Oyster Bay Fire Company No. 1 purchased this 1910 CGV hose truck. Standing from left to right are Peter Golden, William Black, and Ralph Walston, who was the first Oyster Bay firefighter to lose his life in the line of duty. On the truck from left to right are Russ Ebbetts, Frank VanValken, and Dick Ebbetts. Sitting in the front of the truck are Peter Layton and Robert Hendrickson. Charles Miller looks on from the right side. (OBFC.)

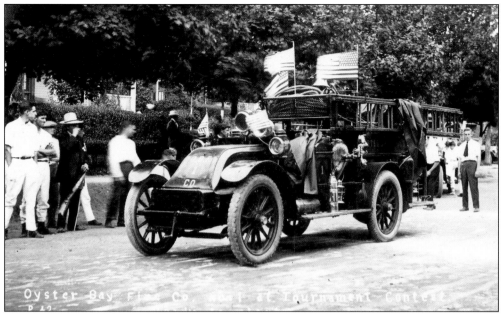

The first parade and drill in Oyster Bay was held on October 20, 1915, and the 1910 CGV was used in the competition. Col. Theodore Roosevelt was a member of the reception committee for the event and he welcomed the visiting firemen in a speech at the Lyric Theatre. Roosevelt stayed to watch some of the competitions and stated that he was thoroughly impressed with the enthusiasm and competition displayed by the firemen. (RYC.)

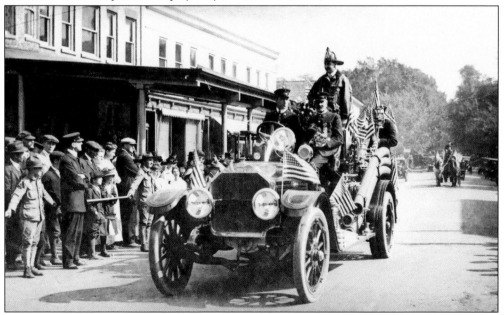

On July 4, 1916, the largest parade the village had ever seen was held in Oyster Bay. J. Stuart Blackton, who lived on Cove Neck next to Col. Theodore Roosevelt, brought his Vitagraph Film Company crew to Oyster Bay to film the entire parade. In October 1916, Blackton presented the finished film to the community at a special showing in the Lyric Theatre on Audrey Avenue. (OBFC.)

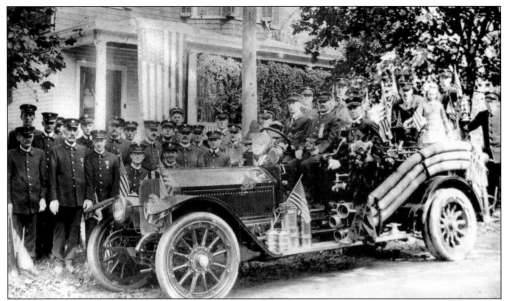

Atlantic Steamer Company No. 1 poses on East Main Street at the start of the 1916 parade. Identified here are E. Hendrickson, J. Germain, L. Bennett, H. Perrine, G. Clarke, D. Starkes, P. Stoddard, W. Starkes, R. Hennessey, F. Moore, J. Delong, B. Oakley, H. Griffen, D. Smith, M. Heenan, C. Ludlam, W. Wanser, J. McKenna, W. Bryce, J. Dean, W. Wright (driver), W. Lent, R. Hendrickson, B. H. Powers, G. Clark Jr., W. Dunn, and T. Smith. The little girl on the truck is Gloria Clark. (JEH.)

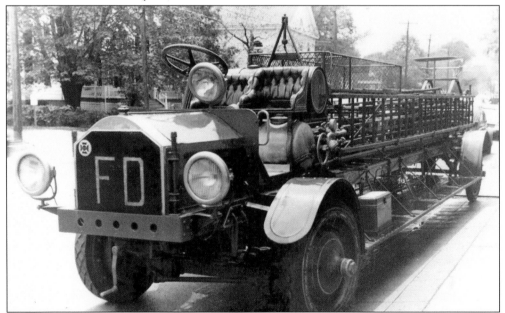

On February 10, 1917, Oyster Bay Fire Company No. 1 took delivery of this American LaFrance type 33 front-wheel-drive tiller truck. The 1916 tiller truck remained in active service with the company until 1956. It was then used only for parades until 1962, when it was donated to the American Museum of Fire Fighting at Hudson, where it presently remains proudly on display. (JEH.)

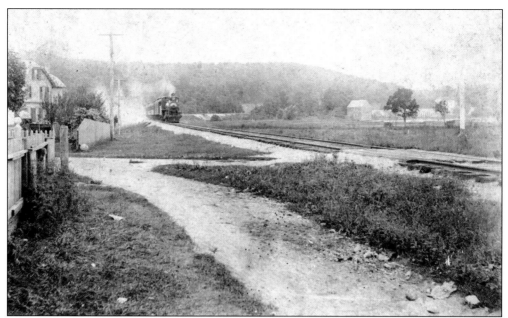

The Long Island Railroad extended the line into Oyster Bay on June 24, 1889. More than 200 residents of the village travelled to Long Island City the night before so they could ride the first train into Oyster Bay. Over 1,000 residents assembled at the new station to greet the first train. In this 1891 photograph, the half-past-five afternoon train approaches the Bayside Avenue crossing. (OBHS.)

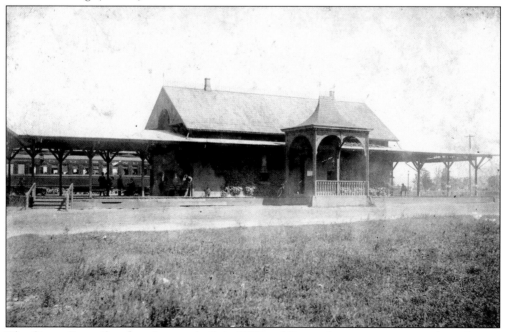

The Oyster Bay railroad station was built in 1889 and featured an ornate porte cochere. Locust Valley had previously been the end of the line, and when the line was extended to Oyster Bay, the turntable from Locust Valley was relocated to Oyster Bay. The turntable had to be replaced in 1902, however, as new, larger engines were placed in service. (OBHS.)

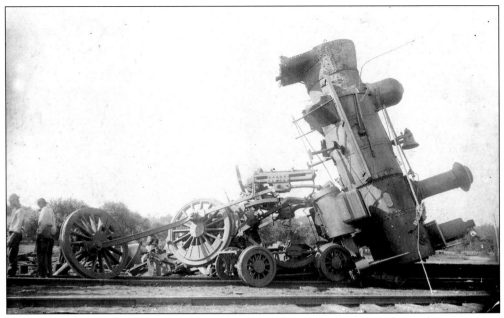

On the morning of September 9, 1891, engine No. 113 was awaiting its 7:08 a.m. departure time when it erupted in a violent explosion that awakened the entire village. Engine No. 113 was a 4-4-0 type built by the Rogers Company and was only two years old. Railroad officials were at a loss to explain why it had exploded. James Donaldson, engineer; Townsend Dickenson, fireman; and Michael Mahoney, brakeman, were all killed in the explosion. (JEH.)

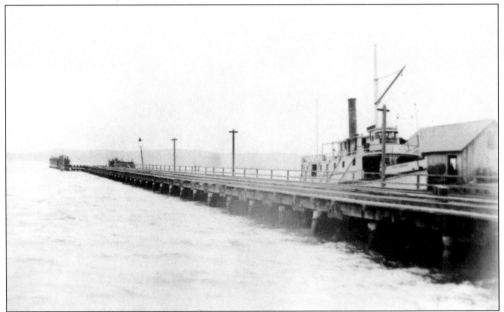

In 1891, the Long Island Railroad began construction of this 1,000-foot-long dock at Oyster Bay's commercial wharf. The idea was to take fully loaded railcars and transport them, via the steamer *Cape Charles*, across Long Island Sound to Wilson's Point, Connecticut. At Wilson's Point, the cars would be connected to the Housatonic Railroad and continue on to Boston. By the end of 1892, the entire project was abandoned due to very poor revenues. (JEH.)

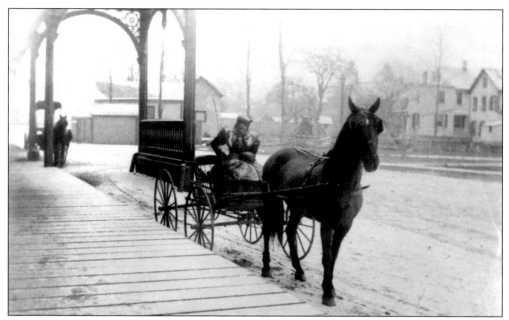

The porte cochere did not always do its job of protecting arriving and departing passengers and their drivers. In this photograph taken in 1895 by William H. C. Pynchon, his future wife Carrie Moyses patiently waits in the snow for an arriving passenger. William H. C. Pynchon and Carrie Moyses were married the following year. Their son Thomas R. Pynchon became Oyster Bay town supervisor in 1960. (JEH.)

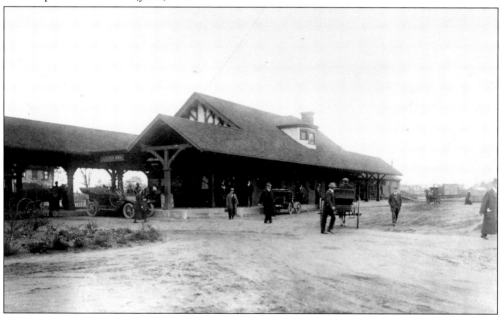

In 1902, the station at Oyster Bay underwent a major renovation. The porte cochere was removed, the wooden platforms were replaced with concrete, and the protective canopies were extended. A new turntable was also installed to accommodate the larger engines that were being placed in service. The building, barely visible to the left, under and behind the canopy, is the Jervis Pottery Works. (NCM.)

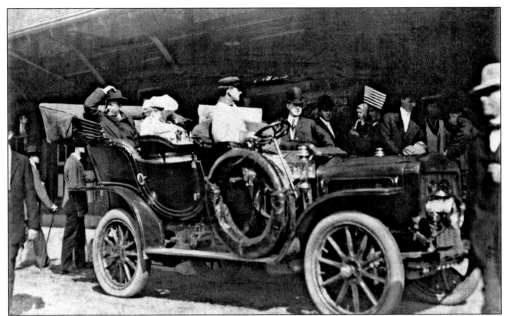

Theodore Roosevelt was a regular and enthusiastic user of the Long Island Railroad. When he was president of the New York City Police Board, he regularly rode his bicycle down from Sagamore Hill and caught the train from Oyster Bay into New York City. In this photograph, Pres. Theodore and Edith Roosevelt arrive at the station in a car on September 25, 1907, to depart for Washington. (TRA.)

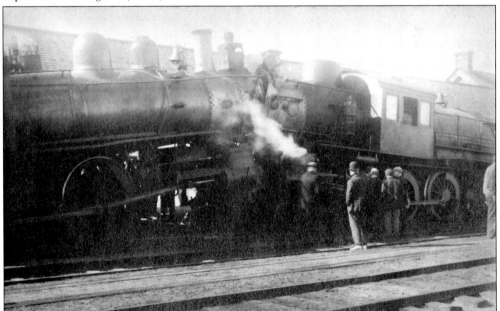

On the morning of March 7, 1910, an unscheduled freight train lost braking while coming into Oyster Bay. The engineer of the departing 8:46 a.m. passenger train was alerted, however, and began backing up his train, thereby lessening the impact. Both engines were heavily damaged in the collision, but the railroad had the scene of the crash cleared up in only three hours and service was not interrupted. (RYC.)

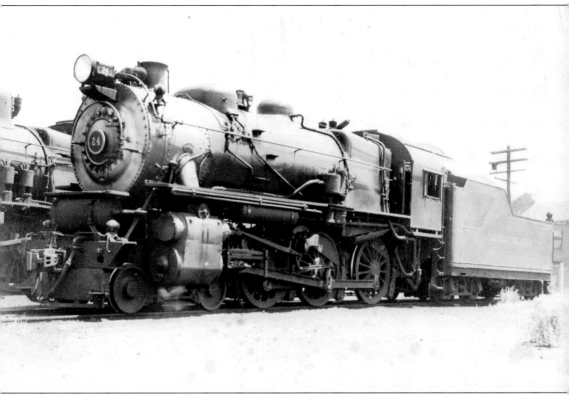

The powerful G5 engines were placed in service in the early 1920s. Shown here at Oyster Bay is engine No. 24, which was placed in service in 1924. The G5s remained in service until the very last G5 passenger steam locomotive, No. 35, left the Oyster Bay station in October 1955. Locomotive No. 35 returned to Oyster Bay, however, and is presently the focus of restoration as a part of the Oyster Bay Railroad Museum. (OBRM.)

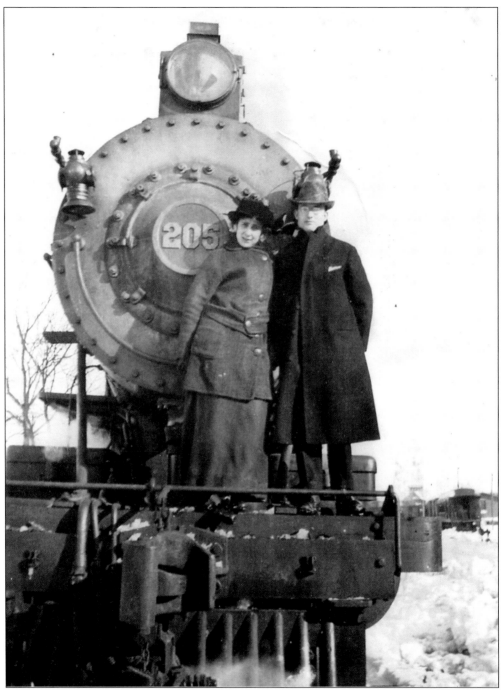

Perhaps, sensing the impending replacement of the 4-4-0 engines, Francis X. Moore and his wife pose on the front of engine No. 205 at the Oyster Bay railroad yards. Engine No. 205 was an American type 4-4-0 built by the Pennsylvania Railroad and was in service on the Long Island Railroad from 1905 to August 1927. (OBRM.)

Five

SCHOOLS AND CHURCHES

In 1801, James Farley led a group of concerned citizens who raised money for this building, the Oyster Bay Academy. Rev. Marmaduke Earle of Stamford, Connecticut, was hired to be the head of the academy. Among the school's early students was William T. McCoun, who became chancellor of the New York Chancellery court system. In 1844, a new school was built on South Street and the academy building then became the Christ Church rectory. (JEH.)

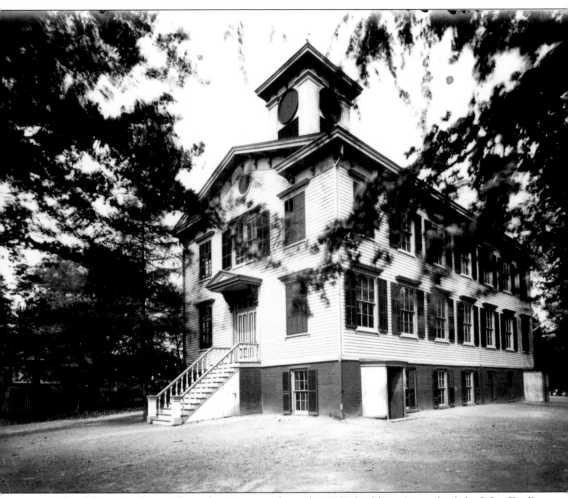

School Street in Oyster Bay takes its name from this 1871 building. It was built by John Dudley Velsor, a contractor who lived next door to the site. Eighty-six-year-old chancellor William T. McCoun spoke at the formal dedication on December 27, 1872, and related his experiences at the Oyster Bay Academy while being taught by Rev. Marmaduke Earle. The bell for the school was cast by McNeely and Kimberly Foundry of Troy. (JEH.)

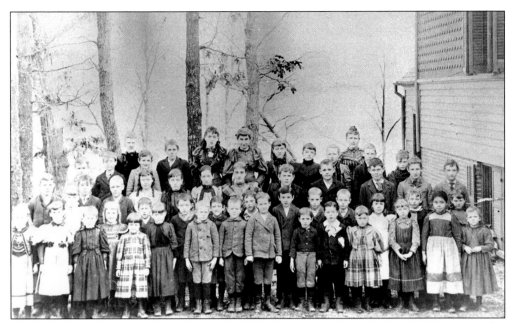

M. A. McDonald was hired as the principal for the new public school. Julia Thurston, who was raised on Hamilton Avenue in Oyster Bay, was the assistant principal. Thurston was later known by the title preceptress of the school and continued to teach in the Oyster Bay school system until 1924, when she moved with her sister to Baltimore. This photograph shows the elementary school students at the Oyster Bay school in 1875. (NCM.)

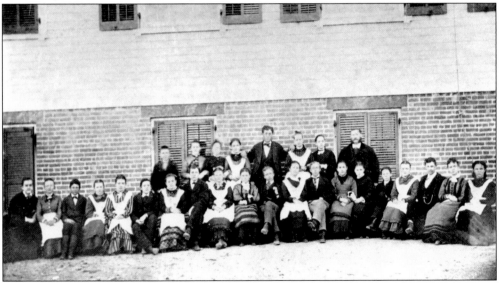

In 1875, this photograph was taken of the high school students. Seen from left to right are (first row) Annie Ludlam, Emma Vail, Chester Painter, Annie Cheshire, Jennie Sammis, Albert C. Wakeman, Ida Gildersleeve, Henry C. VanCott, Annie Larrabee, Lizzie Marchant, Bert Wright, Gussie VanVelsor, Ed Sammis, Delia Terry, Jennie VanVelsor, Will Brower, Alice Cheshire, Ed Ludlam, Lizzie Kittle, and Kate Flanagan; (second row) Peter McQuade, two unidentified, Mame Sterling, Townsend Downing, Libbie Dodd, Ida Bayles, and M. A. McDonald (principal). (NCM.)

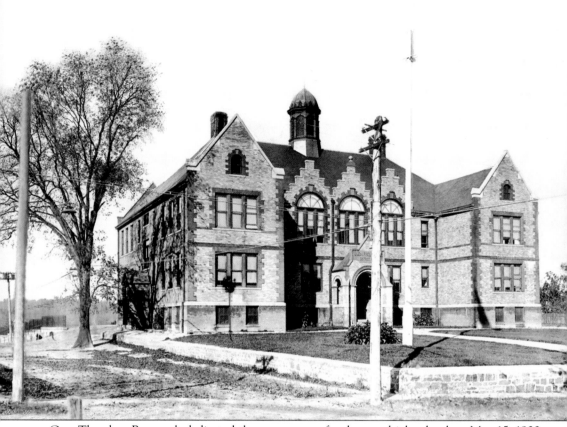

Gov. Theodore Roosevelt dedicated the cornerstone for the new high school on May 15, 1900. The new Oyster Bay High School was delayed in construction due to a disastrous July storm that did heavy damage to the project. In October 1900, the board of education had to go back to the voters to ask for an additional $7,700 so the school could be finished. The bonds were issued by the Town of Oyster Bay and the school building was completed in time for the beginning of the 1901 school year. When completed, it was touted by the press as being the finest school building in the county. (JEH.)

Although the new school was not ready for the 1900 graduating class, the members of the class certainly were. Graduation exercises were held in the Methodist church on South Street on June 12, 1900. The entire graduating class consisted of these four young ladies. From left to right are Elma Downing, Sally Robinson, Grace Talmage, and Carrie Moore. (OBHS.)

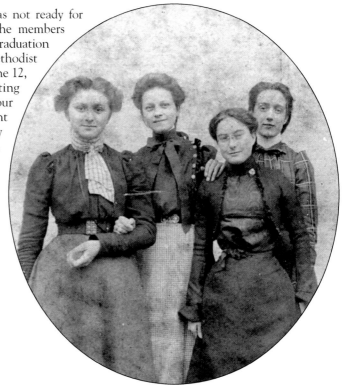

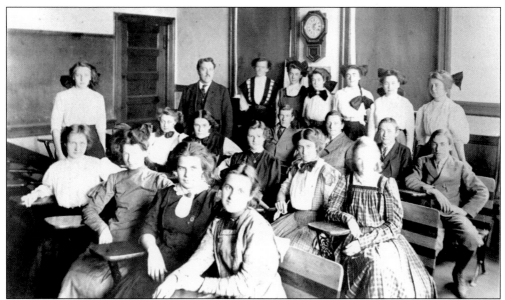

By 1912, the graduating class had grown substantially. Seen here from left to right are (first row) Grace Duryea, May Dunn, Ethel Groom, and Gertrude Miller; (second row) Mabel Hendrickson, Louise Canning, Evelyn Molineaux, Harriet Cheshire, and Chickie Dean; (third row) Wig Dickson, Simeon Hauser, Charles Hainesfield, and Howard Hastings; (fourth row) May Barto, Thomas Colby (principal), Martha Hoyt, Marie Irwin, Marie Webster, Martha Hoagland, Kate Hanophy, and Mabel Hauser. (OBHS.)

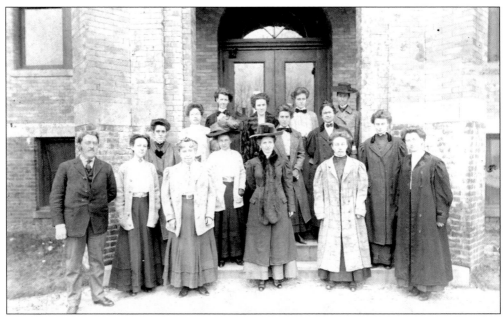

The Oyster Bay High School faculty poses in front of the school for this 1909 photograph. Thomas Colby was the principal of the high school. The second woman from the left is Julia Thurston, who taught at the Oyster Bay schools from 1872 through 1924. All the female teachers were unmarried in those days, as it was against New York State education law for a female schoolteacher to be married. (OBHS.)

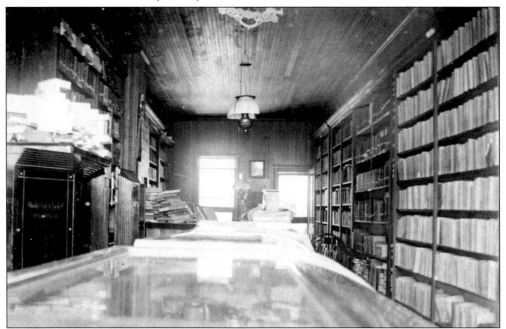

Oyster Bay's first library was located in a room at the rear of Hegeman's dry goods store on the corner of South Street and Audrey Avenue. The library was referred to as the People's Reading Room and Lyceum when it first opened in 1873. When this photograph was taken in 1900, it was known as the People's Library and Reading Room. (JEH.)

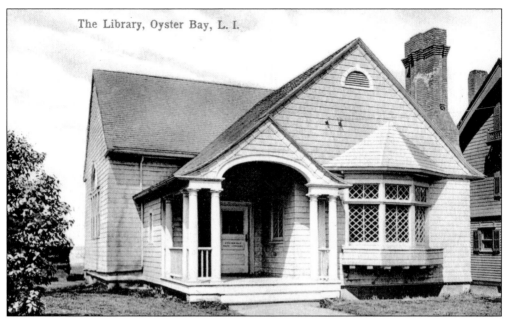

The Library, Oyster Bay, L. I.

On October 2, 1900, Gov. Theodore Roosevelt spoke at the cornerstone ceremony for the new Oyster Bay Free Library. Roosevelt had hosted Adm. George Dewey in Oyster Bay the previous Friday and declared a school holiday so all the schoolchildren could see the hero of the Spanish-American War. Dewey was honored in a large parade in New York City on Saturday, September 30, 1900. (JEH.)

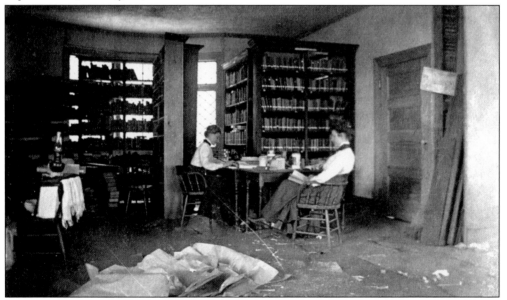

There was a long time between the cornerstone laying and the completion of the library building. The cornerstone had been laid before the money to build the library had been raised. By the time the money was raised, the cornerstone had disappeared. The building was finally completed in May 1901, and Louise Denton was hired as librarian to arrange the books. Denton is shown here with her assistant arranging books, while the last details of construction were being completed. (JEH.)

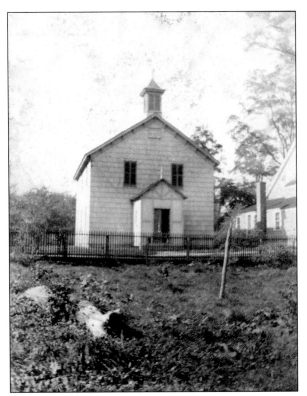

A Baptist Church was organized in Oyster Bay in 1700. A church building was erected in 1724, but no trace or image remains of it. When a new building was built in 1807, the original church building was moved across the street and later became a stable. The Baptist Church at Oyster Bay was the first Baptist church anywhere in New York. This 1807 building was built on the same West Main Street site as the original church building. (JEH.)

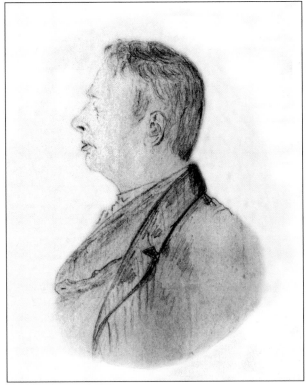

Rev. Marmaduke Earle came to Oyster Bay as the teacher at the Oyster Bay Academy in 1802. Reverend Earle also became the pastor at the Baptist church from April 1802 until his death in 1856 at age 87. This drawing of Reverend Earle was made by one of his daughters. (OBHS.)

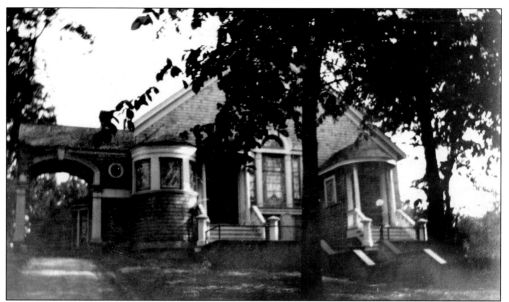

In 1908, the 1807 Baptist church building was moved farther back on the church lot and this new building was erected. Rev. Charles Wightman, who had become the pastor of the church in 1868 was born in Middletown, Connecticut, and spent his early years as an engineer. His father, Skillman King Wightman, was a prominent attorney in New York City. Reverend Wightman's brother, Edward King Wightman, was killed in the Civil War on January 15, 1865, at Fort Fisher, North Carolina. (JEH.)

In 1872, Rev. Charles Wightman married Mary Earle, granddaughter of Rev. Marmaduke Earle. They lived in the same house as had Mary's grandfather Marmaduke Earle. Mary Earle and her sister had started a school for girls on Orchard Street in the old window blind factory of George Dickinson. Charles and Mary Wightman had no children. Mary died on January 2, 1901. (OBHS.)

Rev. Charles Wightman continued living in the home on South Street after Mary Earle's death in 1901. He became a very influential person in the affairs of the village and participated on many committees beyond the scope of his pastorate at the Baptist church. He continued as pastor throughout his life and died at age 97 in 1933. He was buried at the Wightman family cemetery in Connecticut. This photograph shows Reverend Wightman in his 90s with his housekeeper. (OBHS.)

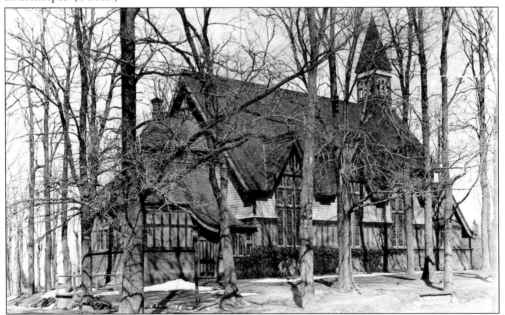

Christ Church traces its origins to 1705 when Episcopal services were first held in Oyster Bay by visiting clergy from Hempstead. This building on East Main Street was the third church building on the same spot and was built in 1878. After his marriage to Edith Kermit Carow in 1886, Theodore Roosevelt became a regular attendee at Christ Church. This photograph was taken by Dr. George Faller in 1895. (OBHS.)

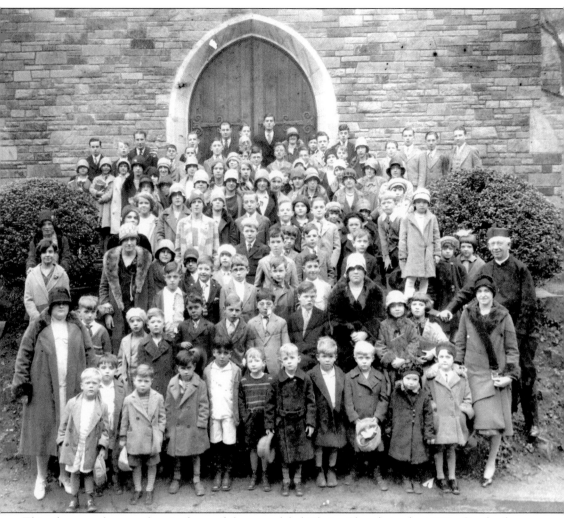

This photograph was taken in front of the remodeled Christ Church in the 1920s. On the far right, second row, is Rev. George Talmage, rector of Christ Church, who officiated at Theodore Roosevelt's funeral at Christ Church on January 8, 1919. In the back row, just left of the door, is the author's father, Victor Clifford Hammond, who sang in the choir for many years. (OBHS.)

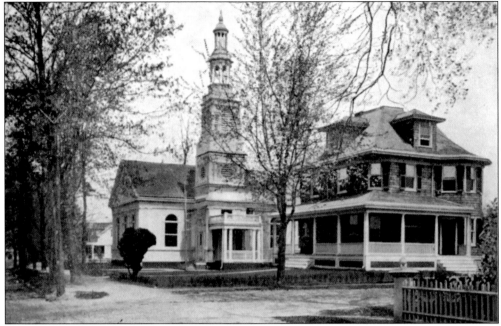

The first Methodist church in Oyster Bay was built in 1858 on Orchard Street. In 1891, the congregation acquired property on South Street from the Burtis family and built the church shown here in 1894. The new church was dedicated on March 24, 1895. In 1913, the building was raised and a basement was constructed for a Sunday school. (JEH.)

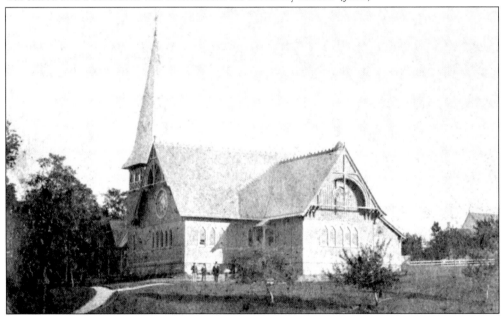

In 1844, a Presbyterian church was built on the corner of East Main Street and South Street. This photograph was taken shortly after a new church building was completed in 1873. Theodore Roosevelt's father was an elder at the First Presbyterian Church at Oyster Bay. William Lincoln Swan, the founder of the Seawanhaka Corinthian Yacht Club, was the organist and choir director at the church for 51 years. (JEH.)

These seven young ladies are dressed in all their finery for this photograph, taken at the First Presbyterian Church in 1894. The girls are, from left to right, (first row) Jennie Downing; Gertrude Larrabee, born on January 27, 1885; and Mina Pearsall, born on January 3, 1887; (second row) Ada Schenck, born on March 11, 1885; Celia Moore, born on December 16, 1884; Sarah Townsend; and Ida Smith. (OBHS.)

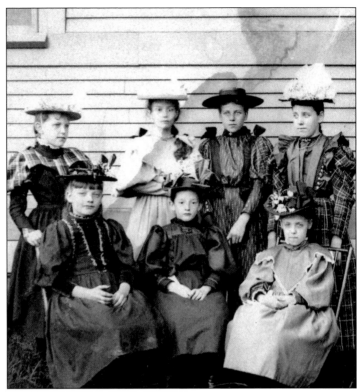

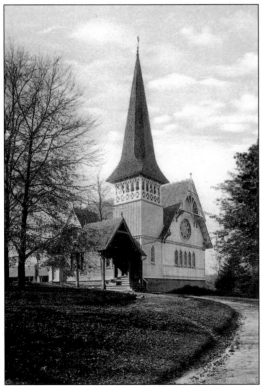

The First Presbyterian Church at Oyster Bay was designed by J. Cleveland Cady, a graduate of Trinity College in Hartford, Connecticut. Cady went on to design many notable buildings, including the old Metropolitan Opera House in New York City and the American Museum of Natural History in New York City. He also designed many academic buildings at Yale University, Trinity College, Williams College, and Wesleyan University. (JEH.)

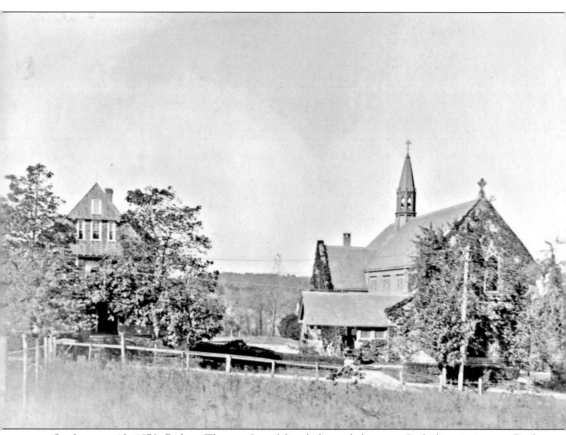

On January 13, 1870, Bishop Thomas Loughlin dedicated the new Catholic mission on Bayles Hill. Fr. J. J. Crowley, pastor of St. Patrick's Catholic Church in Huntington, was appointed by Bishop Loughlin in 1881 to minister to the needs of the Oyster Bay mission. Father Crowley made weekly trips over to Oyster Bay to conduct early mass at 8:00 a.m. before returning to Huntington in time for his 11:00 a.m. mass there. St. Dominic's became a parish in 1895 with the appointment of Fr. John L. Belford as pastor. Plans submitted by Ingal and Almirall, architects, were approved in October 1896 and construction proceeded rapidly. The outside of the building was covered with grey Connecticut stone, which was transported across Long Island Sound by barge. The new church was dedicated on Thanksgiving Day 1897. (JEH.)

Six

THE GOLD COAST

Louis Comfort Tiffany was born in New York City in 1848. His father, Charles Lewis Tiffany, was a founding partner of Tiffany and Young, which became Tiffany and Company in 1853. In 1890, Louis Comfort Tiffany became a summer resident of Oyster Bay when he built his summerhouse, the Briars. His wife Louise was listed as a member of the Oyster Bay Golf Club in its 1895 membership book, but Louis Comfort Tiffany was not a member of the club. (OBHS.)

In 1906, Louis Comfort Tiffany completed construction of his 110-room mansion, which he named Laurelton Hall. The mansion displayed a strong Moorish influence, reflecting Tiffany's love of Moorish art and architecture. The mansion was a veritable museum of Tiffany artwork including *The Bathers* window and the *Flower, Fish and Fruit* window, which he originally created in 1885 for a home in Baltimore. (OBHS.)

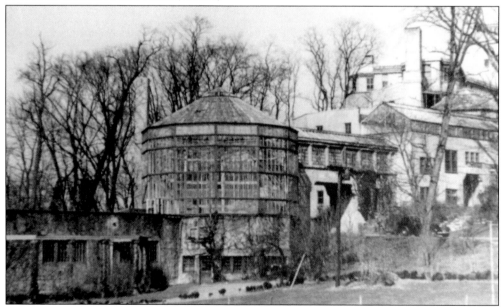

Laurelton Hall was the scene of many lavish parties that sometimes went on for several days. Photographs survive of Tiffany dressed as an eastern potentate at one of his famous costume balls. The guests at his parties included the wealthiest of New York City and Long Island's Gold Coast like the Whitneys, Vanderbilts, Astors, and visiting European royalty. (OBHS.)

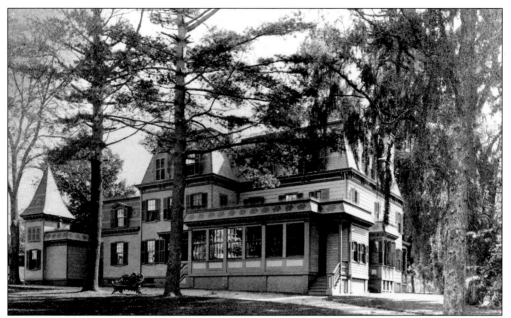

Arthur Delano Weeks was a ninth-generation descendant of Francis Weeks, who settled in Oyster Bay before 1660. Weeks built this home on Cove Hill about 1880. After the death of his first wife, Weeks lived for a time near Morristown, New Jersey, where he was a founder and the first president of Baltusrol Golf Club when it formed in 1895. He was also a member of the Oyster Bay Golf Club. (OBHS.)

Harold Hathaway Weeks, son of Arthur Delano Weeks, is shown here in 1881. It was the custom in those times, particularly among the wealthy, to dress young boys like girls until they reached about age five. Harold Hathaway Weeks grew to be a robust young man and an All-American football star at Columbia University. (OBHS.)

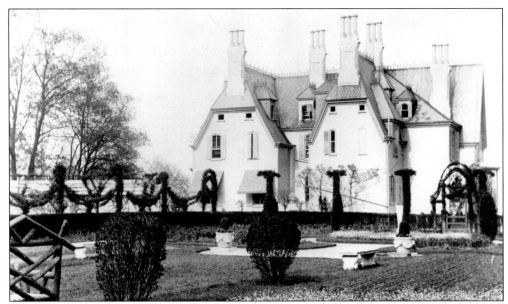

James William Beekman built this Victorian Gothic Revival–style house in 1863. The house, known as the Cliffs, is listed on the National Register of Historic Places and was designed by Henry G. Harrison who also designed the Cathedral of the Incarnation in Garden City, New York. Beekman was a New York State senator in the 1880s and a founding member of Seawanhaka Corinthian Yacht Club in Oyster Bay. He was often seen sailing his yacht *Mirth* in Oyster Bay Harbor. (OBHS.)

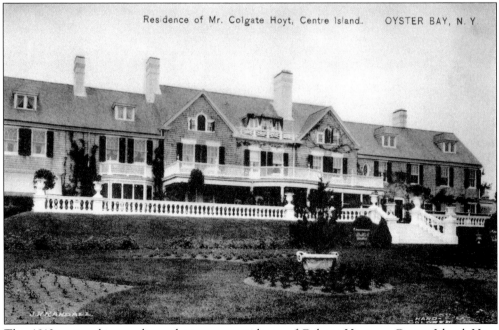

This 1910 postcard image shows the summer residence of Colgate Hoyt, on Centre Island. Hoyt bought the property in 1893 and completed the home in 1895. Hoyt was a mining magnate and commuted to New York City via the steam launch *Seawanhaka*. He was a member of both the Oyster Bay Golf Club and the Seawanhaka Corinthian Yacht Club. (JEH.)

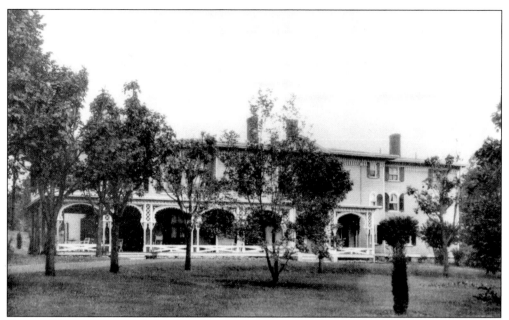

George Thompson owned this large house on East Main Street, but he liked to go to the mountains in the summer. In 1906, he rented his house to a New York City banker named Warren who hired an Irish cook. Shortly after the cook arrived in August 1906, several members of the Warren household became ill with typhoid. After much investigation, the cook was identified as a carrier of typhoid. Her name was Mary Mallon and the New York newspapers gave her the name "Typhoid Mary." (OBHS.)

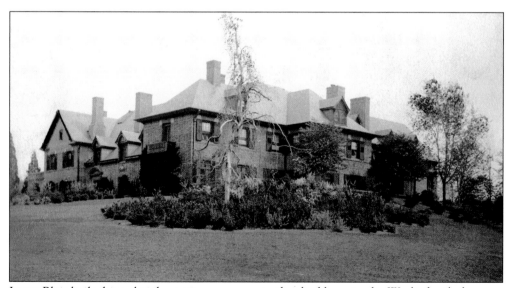

James Blair built this palatial mansion on property that had been in the Weeks family for more than 200 years. Blair was an insurance executive and the house was near Sandy Hill Road. The access roads through the large property later were called Blair Road. (OBHS.)

Jacob Henry Schiff was born in Germany and became a partner in the banking firm of Kuhn, Loeb and Company. When Pres. Theodore Roosevelt was searching for qualified people to fill his cabinet he turned to Jacob Schiff, who recommended Oscar Strauss, the first Jew appointed to a cabinet-level position. Jacob Schiff's son Mortimer Schiff built the palatial home shown below. (JEH.)

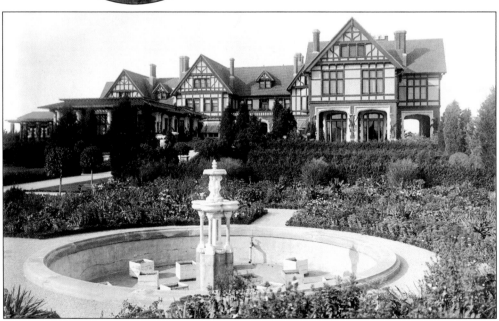

Mortimer Schiff began acquiring property in Oyster Bay in about 1904 and completed building this mansion called Northwood in 1906. Among his property acquisitions was the old Oyster Bay Golf Club, which Mortimer Schiff used as his personal course until his death in 1932. His son John Mortimer Schiff thought the house was too big and too gloomy so he tore it down and replaced it with a new building, resembling a French chateau, on the same site. (OBHS.)

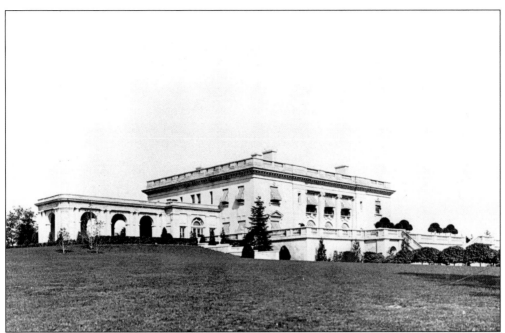

Many of the Gold Coast estates and mansions were built on the old family farms. Stockbroker Charles I. Hudson built this mansion of Indiana limestone on property that had been the author's great-great-great-grandfather's 168-acre farm on the Jericho Road. The 60-room mansion was surrounded by lush gardens. (NCM.)

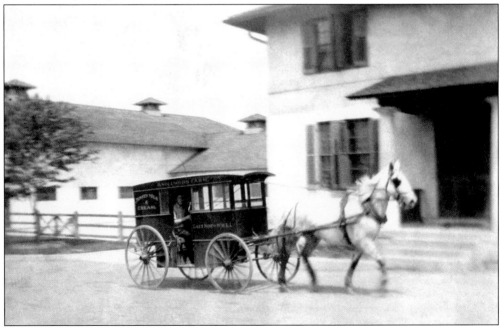

Hudson's estate encompassed a total of more than 300 acres, which included a fully operating dairy farm with prized herds of Jersey cattle. The farm operated under the name Knollwood Dairy, after the name of Hudson's estate. Shown here in a family snapshot is the author's 18-year-old grandfather Alvah Martling driving the new Knollwood delivery wagon in 1910. (JEH.)

J. Stuart Blackton was the founder of the Vitagraph Film Studio. He built his mansion Harbourwood on Cove Neck next to Theodore Roosevelt's home at Sagamore Hill. Blackton had become friends with Roosevelt when Roosevelt asked Blackton to bring his film equipment to Cuba to film the war in 1898. In 1916, J. Stuart Blackton was named grand marshal of the Fourth of July parade in Oyster Bay and brought his Vitagraph crew to Oyster Bay to film the parade. (JEH.)

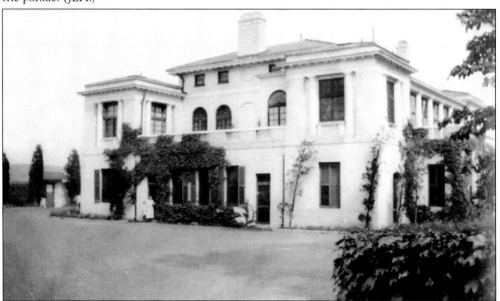

J. Stuart Blackton was an avid yachtsman and built this boathouse on the shore of Cold Spring Harbor. Blackton lost much of his fortune in 1920, and the boathouse and property were acquired by William Leeds and the building became known as Leeds Boathouse. During the Roaring Twenties, Leeds hosted gala parties in the upstairs party room of the boathouse. His guests often included movie stars and the biggest names on Broadway. Adele Astaire, sister of Fred Astaire, was badly burned here in a 1928 fire on Leeds's speedboat *Fantail*. (JEH.)

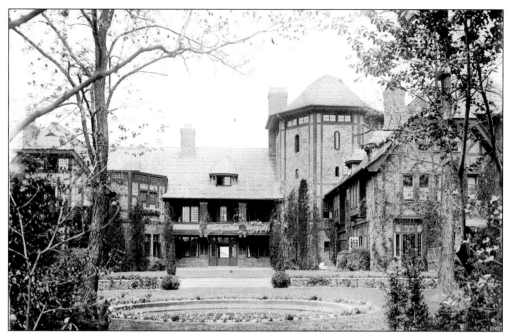

James Byrne built this large mansion on the old planting fields in 1910 but sold it in 1913 to William Robertson Coe. Coe had been born in Worcestershire, England, in 1869 and came to Philadelphia while in his teens. Coe loved American things and in 1911 bought the Buffalo Bill Ranch in Cody, Wyoming. (JEH.)

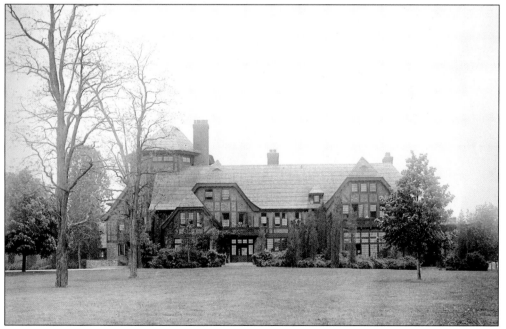

The finishing touch to Coe's mansion was going to be the Carshalton Gates, which were built in England in 1712. William R. Coe acquired the gates in an auction in England before World War I, but before he could arrange to have them dismantled and shipped over, his mansion was destroyed by fire in March 1918. (JEH.)

113

The Gold Coast estates also featured many interesting outbuildings. This driftwood teahouse was built by Edward Nelson of Oyster Bay on the grounds of Gracewood on Cove Neck. Gracewood was the summer home of James K. Gracie and his wife, who was a sister of Theodore Roosevelt's mother, Martha Bulloch. The photograph was taken in May 1890. (JEH.)

Seven

AROUND THE BAY

The millrace (overflow) provided an extremely well protected spot for Daniel Dykeman Smith's tour boats. Smith came to Oyster Bay to operate the first hydroelectric-generating facility in Nassau County in 1892, which used the overflow from the millpond seen in the distance in this 1905 photograph. He later began building tour boats for the many tourists that visited Oyster Bay. (RYC.)

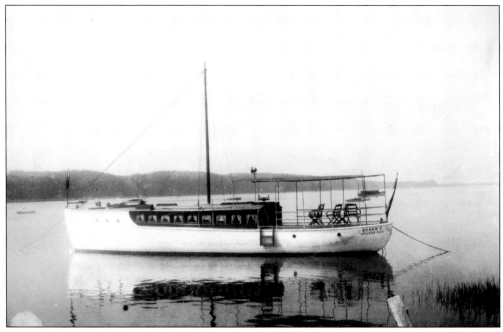

Daniel Dykeman Smith's largest tour boat, the *Evade II*, was 50 feet long at the waterline and was built in Oyster Bay at Duryea's Shipyard. Smith took the *Evade II* to Florida and started up a Miami to Palm Beach tour service. Several of Smith's smaller boats were powered by engines Smith made in John Titus's machine shop. (RYC.)

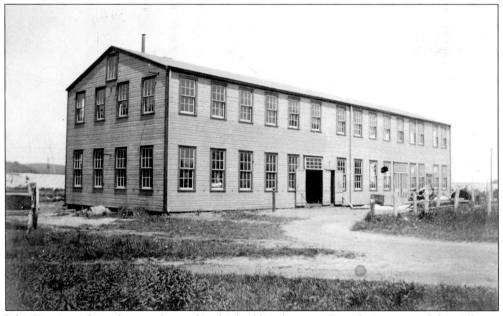

John Titus's machine shop was located in this building between Bayside Avenue and the millrace. The shop was noted for making the Oyster Bay Engine, which was designed and patented by Daniel Dykeman Smith. The small kerosene-powered engines were used for small boats, powering reciprocal saws, and even to power the first press of the *Oyster Bay Guardian* newspaper. (RYC.)

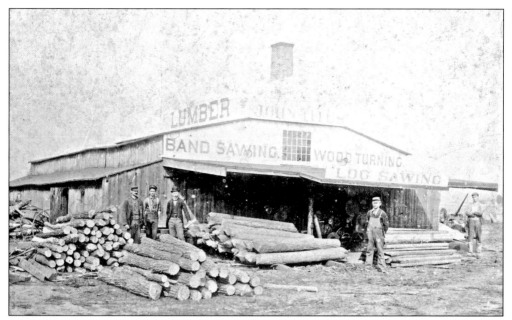

In addition to his machine shop, John Titus also operated this log sawing and wood turning plant near his machine shop. The area became known as Johnstown, some say because of John Titus and some say it was named after the Johnstown, Pennsylvania, floods. From left to right are John Titus, John Robinson, Daniel Dykeman Smith, and John Bells. The man on the far right is unidentified. (RYC.)

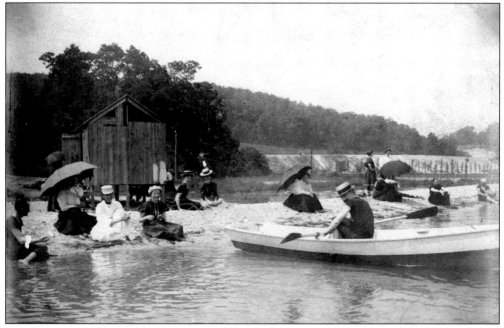

This photograph of bathers, at what was later known as Beekman Beach, was taken on August 22, 1899. In the background can be seen the grade of the Long Island Railroad tracks as they make their way toward what was called the Mill Neck Cut. The cut was needed to overcome a steep grade coming out of Oyster Bay. The bathers are unidentified. (RYC.)

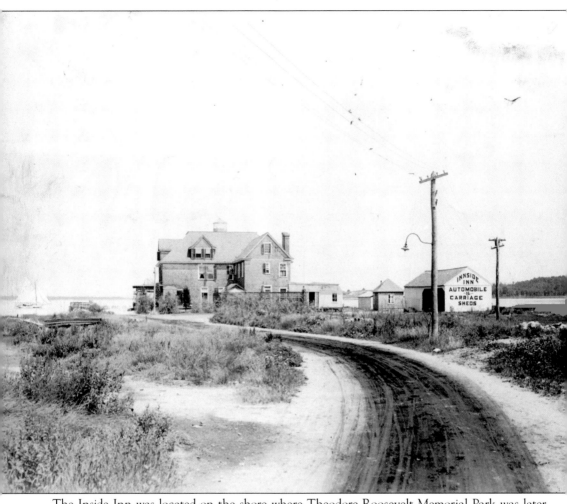

The Inside Inn was located on the shore where Theodore Roosevelt Memorial Park was later built. The inn was referred to as a casino, although there was no gambling. It was a popular local spot for dances and other social events. The inn was destroyed by fire in about 1920. (JEH.)

Steamboat service to Oyster Bay began in the early 1830s. The dock seen in this photograph was built about 1832 along the shore in Oyster Bay Cove. Steamboat Landing Road takes its name from this dock. The service stopped operating in the 1870s due to a lack of maintenance and poor patronage. This photograph was taken in September 1881. (OBHS.)

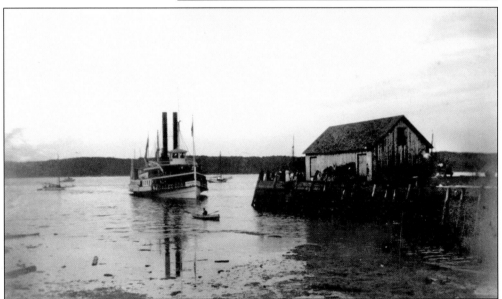

In 1880, the Oyster Bay Commercial Dock Company was formed and built a wharf at the foot of South Street. With this new dock, which was more convenient to the village, a new steamboat service was instituted. In this 1885 photograph, the steamer *Shadyside* nears the commercial dock. The *Shadyside* left Oyster Bay daily at 6:40 a.m. making stops for additional passengers at Laurelton and Lloyd's Dock and then arrived at pier 23 at the foot of Beekman Street in New York City. (JEH.)

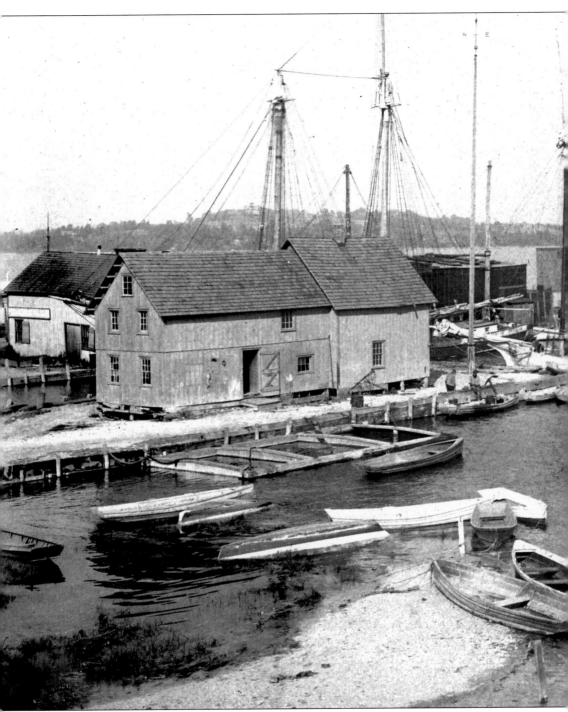

The commercial dock became known as the oyster dock shortly after the oyster industry began flourishing in the 1880s. The early Dutch explorers named the area about 1615 when Adrian Block made his explorations of Long Island Sound. The earliest written notation of the name was in June 1639 when Capt. David Pieter Devries recorded in his journal that he had anchored in Oyster Bay, which was named by his nation because of the succulent bivalves to be found

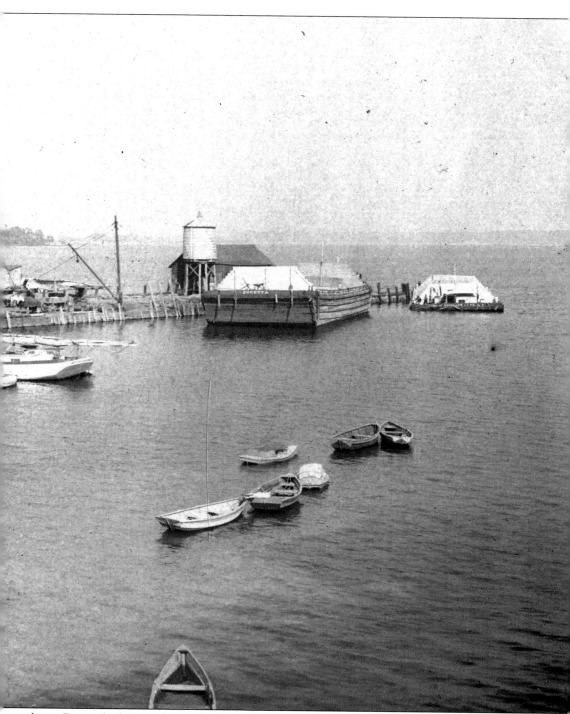

there. Oysters had always been a food resource since the days of the early settlers, but oystering did not become a commercial venture until about 1880, when the Town of Oyster Bay began issuing underwater leases for harvesting oysters. The commercial dock expanded to include various maritime-related merchants. (JEH.)

The Frank M. Flower Oyster Company began operations in 1887. One of its boats was the *Mayflower*, shown here as it arrives in New York City to deliver a load of freshly harvested oysters in the middle of winter. (OBHS.)

On the southwest tip of Centre Island was the Centre Island Brick Company. The Smith and Ludlam families had settled Centre Island in the 1600s and started the brickyard in the early 1800s. The dock at the brickyard was over 600 feet long. Centre Island bricks were used to build the Steinway Piano Factory in Astoria, Queens. The brickyard ceased operations in 1904. (OBHS.)

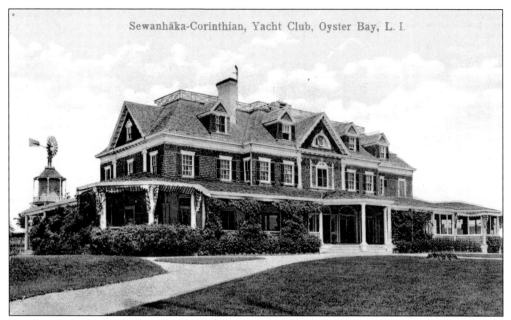

The Seawanhaka Corinthian Yacht Club was organized in 1871 by Commodore William Lincoln Swan. This clubhouse was opened in 1892 on the eastern shore of Centre Island. The club membership included Theodore Roosevelt and his cousin Emlen Roosevelt, along with many of the residents of the Gold Coast estates. (JEH.)

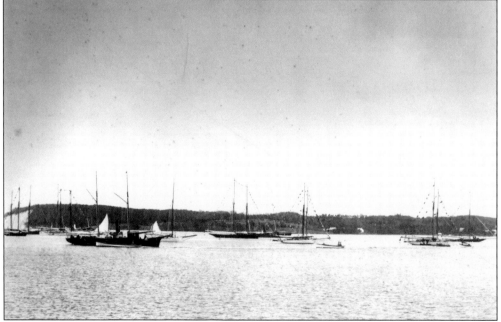

Seawanhaka Corinthian Yacht Club hosted many notable racing events and the waters of the bay were frequently filled with some of the largest sailing yachts in the world. J. P. Morgan's yacht *Corsair* was often seen at Seawanhaka. Morgan lived nearby in Glen Cove. This photograph, taken about 1900, shows some of the large sailing yachts at anchor in the waters off the club grounds. (OBHS.)

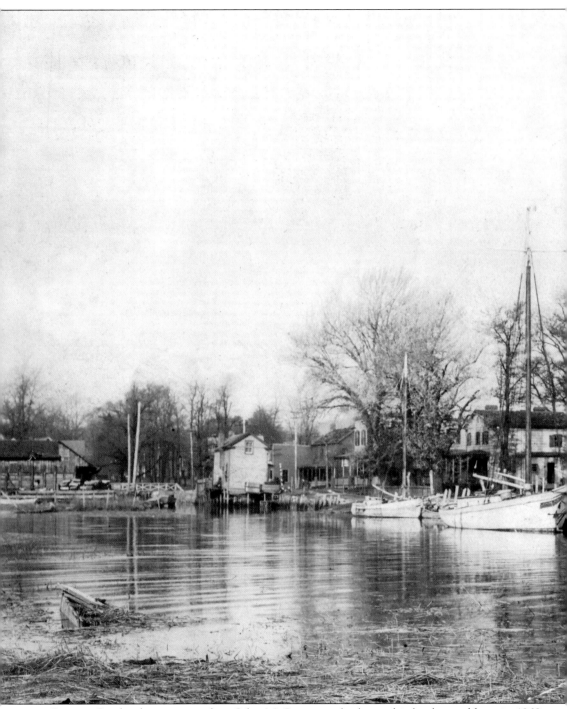

Sammis Creek takes its name from John M. Sammis, who began his lumberyard here in 1868; the lumberyard can be seen in the extreme left of this 1906 photograph. The building built on pilings above the creek is John Gerardi's barbershop. Gerardi was the personal barber of

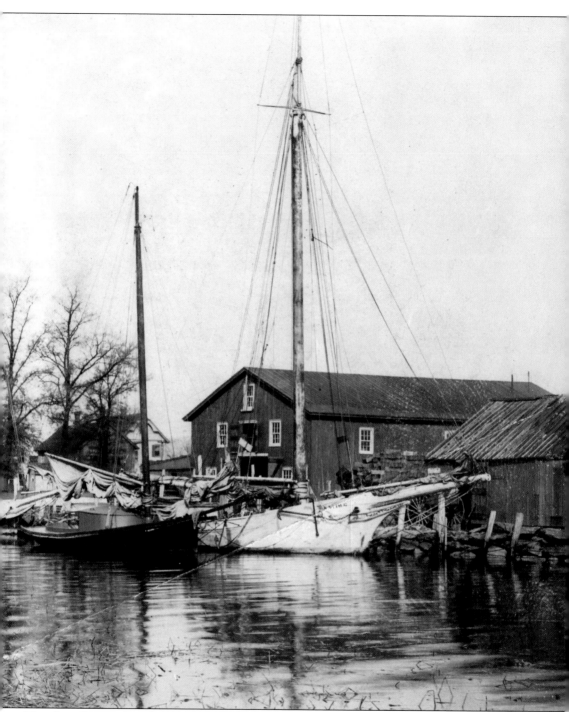

Theodore Roosevelt. The various boats are oyster sloops and vessels used in the coastal shipping trades. The large building to the right is the marine supply warehouse operated by the Hutchinson family. (JEH.)

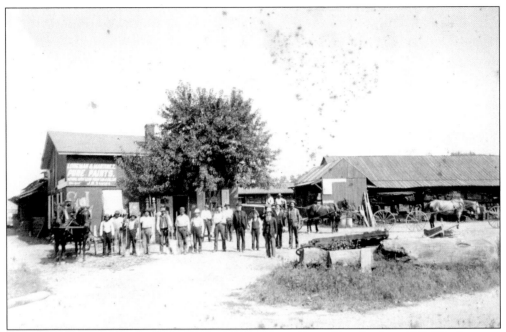

John M. Sammis operated this lumber company from 1868 until his death in 1910. The business was located at the head of Sammis Creek. In this 1890 photograph, Sammis and his staff pose for a formal photograph. John M. Sammis is standing in the center of the picture slightly in front of the rest of the employees. (FRH.)

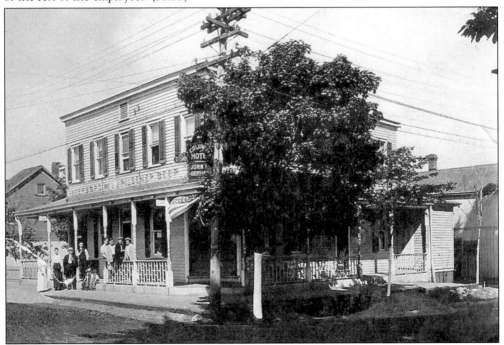

John Gerlich had his Columbia Hotel on the corner of South Street and Bay Avenue, directly across from John M. Sammis's lumber company. The Columbia Hotel was destroyed by fire in 1936. (OBHS.)

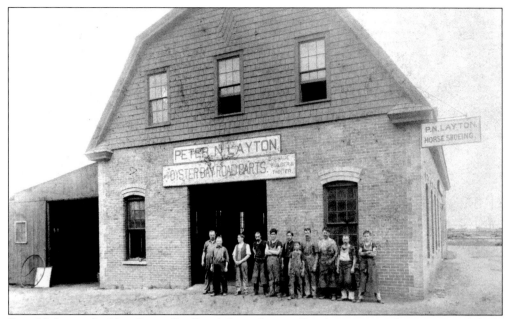

Peter N. Layton had his Oyster Bay Road Carts shop on Bay Avenue near the commercial dock. In this 1902 photograph are George Sasu, harness maker; Frank Cetchak, blacksmith; Charles Conklin, carriage painter; Leonard Hicks, wheelwright; George Stevens, farrier; Frost Layton, farrier; Peter Layton, apprentice; William Stark, blacksmith; and William Sammis, carriage painter. Two of the employees are unidentified. (OBHS.)

The Sagamore Water Company employees pose in front of their Bay Avenue shop, about 1895. The Sagamore Water Company drew water from an artesian well and stored it in three large storage tanks. Locally their water was delivered by wagon. Large shipments were made by the company's two barges. Among the firm's clients were the Proctor and Gamble Company, Pillsbury Flour Company, and the American League Baseball Club. (OBHS.)

DISCOVER THOUSANDS OF LOCAL HISTORY BOOKS FEATURING MILLIONS OF VINTAGE IMAGES

Arcadia Publishing, the leading local history publisher in the United States, is committed to making history accessible and meaningful through publishing books that celebrate and preserve the heritage of America's people and places.

Find more books like this at
www.arcadiapublishing.com

Search for your hometown history, your old stomping grounds, and even your favorite sports team.

Consistent with our mission to preserve history on a local level, this book was printed in South Carolina on American-made paper and manufactured entirely in the United States. Products carrying the accredited Forest Stewardship Council (FSC) label are printed on 100 percent FSC-certified paper.

MADE IN THE
USA